IMAGES
of America

ALLENTOWN AND UPPER FREEHOLD TOWNSHIP

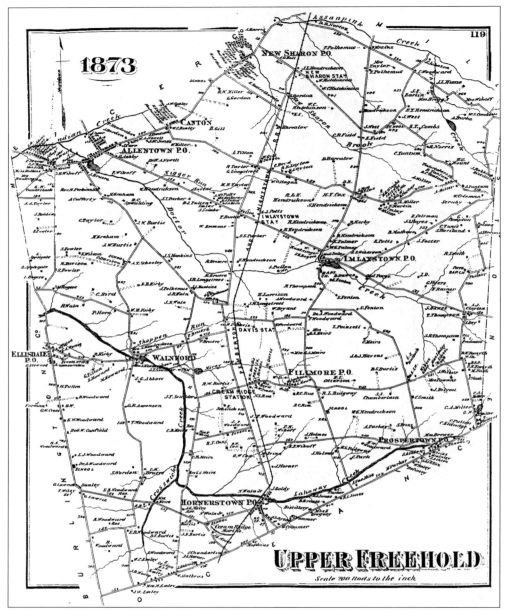

Contemporary travel routes can be traced on this map, plate 119 from the 1873 Beers, Comstock, & Cline *Atlas of Monmouth County*. County Route 524 runs across the top from north of Allentown, and Route 526 goes east from the center of Main Street, passing through Imlaystown on its path beyond the township's eastern border. Interstate 195 (not visible) was built between these two roads. Route 539 runs north-south from west of the Allentown millpond, ending at Tuckerton on Ocean County's shore. The Pemberton & Hightstown Railroad bisected the township north and south, facilitating the development of towns along its route. The long, straight Route 537 at the bottom was a pre-European settlement path to the shore, one realigned in the late 18th century. Province Line Road, on the left, is part of the northwest-to-southeast line that separated the former East and West Jersey Provinces.

IMAGES
of America

ALLENTOWN AND UPPER FREEHOLD TOWNSHIP

Randall Gabrielan

ARCADIA

Published by Arcadia Publishing
Charleston SC, Chicago IL, Portsmouth NH, San Francisco CA

Printed in Great Britain

Library of Congress Catalog Card Number: 00-104066

For all general information contact Arcadia Publishing at:
Telephone 843-853-2070
Fax 843-853-0044
E-mail sales@arcadiapublishing.com
For customer service and orders:
Toll-Free 1-888-313-2665

Visit us on the internet at http://www.arcadiapublishing.com

On the cover: See page 48.

This book is dedicated to the Honorable Theodore J. Narozanick, a western Monmouth County native, who has served admirably in many capacities. Narozanick served in the army for more than five years in the World War II period, rose to the rank of captain, and was decorated for valor. He is a former mayor of Englishtown, one of several public service positions he held prior to being elected to the Monmouth County Board of Chosen Freeholders. He is now in his sixth term and not only serves as the board's liaison to the Monmouth County Historical Commission but is the county's most enthusiastic booster. The author salutes the man, his extraordinary record, and his exemplary spirit.

CONTENTS

ACKNOWLEDGMENTS

The author was fortunate in having a number of contributors who provided exceptional assistance. John Fabiano, the president of the Allentown-Upper Freehold Historical Society, was an early supporter of this project. He gave generously of his and the society's collections, offered encouragement, and found other local supporters.

Ruth Holmes Honadle, the official historian of Upper Freehold Township, has Monmouth County roots that go back 11 generations. She contributed important pictures and information at a time when her own book, *Twixt Crosswicks Creek and Burlington Path,* was in preparation.

Gail Hunton, senior historic preservation specialist with the Monmouth County Park System, is co-compiler of their Historic Sites Inventory. She has long understood, appreciated, and advocated the special qualities of the region's history and environment, and lent generously from the inventory's pictorial archives.

David A. Meirs was generous with the fine image of his magnificent steed and shared his insight into the township's history.

George and Connie Probasco also have long ties to the area. They were generous with their material, patient in awaiting its use, and were willing to go the extra mile to demonstrate a historical fact, literally by taking the author there.

John Rhody is always helpful at the start of a project. His cheerful spirit and eager support enhance the contribution of his fine images from a superlative collection.

Harold "Boots" Solomon became an enthusiastic supporter of the series and was especially helpful with his extensive holdings of western Monmouth County. He would have been pleased to see his outstanding collection so well represented. A big postmortem thanks, Boots.

Glenn Vogel, also known as Mr. Red Bank, is a direct descendant of Nathan Allen, the founder of Allentown. Although he grew up and lives near the shore, he remembers his Allentown roots with a collection that is well represented here.

Alice Ely Wikoff, an accomplished artist, has studiously gathered her town's history for years. She was one of the project's major supporters with both knowledge and pictures.

Thank you to all and to the many others who contributed, including the Allentown Public Library, Wesley Banse, Mary Theoharis Clark, Christine D'Arienzo, Elizabeth Dey, Peggy Dey, Gary Dubnik, Roberta Holmes, Frederick Kneisler, William Longo, Charles Ottinger, Rutgers Special Collections and University Archives, Ramona Truncer, and G. Richard and Frances Walter. And last, but not least, I thank Margaret Stroehleis for facilitating my trip to Walnford.

INTRODUCTION

Upper Freehold Township is Monmouth County's last rural landscape, one that is threatened with development. Allentown is a former market town, squeezed for space, which has had to reinvent itself as mercantile practices have shifted in the suburbanization generation. Their linkage is in one respect more critical in the contemporary world than it is through their history. Now, when a township grows, it is often the borough within its borders that suffers growing pains, as is the case with the borough of Allentown within Upper Freehold Township. Their mutually beneficial historical linkage reflects their present character and is the origin of development angst. Allentown was founded *c.* 1706 when the township was a sparsely settled region of Freehold Township. Its mill was the origin of a commercial center that once had a following in four nearby counties, including parts of Ocean, Mercer, and Burlington. When retailing was town oriented, the shops of Allentown were magnets to people in the surrounding areas. They provided life's essentials and prospered, and the surrounding population brought prosperity without overwhelming the then small village. As development and mercantile patterns changed, business flocked to the highways, building ever larger stores. Hence, the character of market towns in agricultural areas changed everywhere. Many old towns now use charm, crafts, culture, and antiques to create new appeal and therefore economic life. However, they are often unable to accommodate comfortably the new crowds that flock to them. The growth of surrounding communities brought traffic, choking small towns.

Allentown was part of the township until it formed a separate borough in 1889, at a time when New Jersey laws governing municipalities made boroughs easy to establish. New Jersey remains an anomaly with its great number of municipalities: 566 in a small state. A principle of public life in New Jersey acknowledges that it is a home-rule state; its concept of what constitutes a home would create amazement in most other states. Indeed, Allentown used the capabilities of self-government to build a highly esteemed model municipality. Borough laws enabled the more densely settled towns to fund improvements that were unneeded, unwanted, and unfunded by the surrounding farmlands. However, at the start of the 21st century, it is often the larger, growing municipalities that have the revenue-raising capabilities unavailable to fully built boroughs.

Allentown and Upper Freehold Township are at the western extremity of a county that nearly spans the state from the Atlantic Ocean to a few miles from the Delaware River. Although the county has clearly been shore oriented, the Delaware River has often been a focus of western Monmouth County's commerce. It has been said that few on either side of Freehold are aware

7

of the rest of Monmouth County, an oversight that is as unfortunate from the historical view as it is in contemporary life. Upper Freehold and Allentown's history are so unknown that if more attention were given it would be a profoundly neglected subject. As its rich and exciting history is revealed, challenge and opportunity are created for the historian, while even a casual observer can look in awe at the discoveries emerging. Allentown had significance in Colonial times belied by its size. A study ongoing at publication will help secure greater recognition. Its Revolutionary War activity missed the local histories. If one considers only the most significant local Revolutionary War event (the Battle of Monmouth), realize that the British and Hessians were not airlifted to the battlefield; they marched through and around Allentown, while skirmishes were fought throughout the march. Perhaps being out of the way has also helped preserve the landscape. Upper Freehold Township has a fine stock of 18th- and 19th-century farm properties that have escaped development. The size of farms intact in the second half of the 20th century helped create a new industry in the past generation—horse breeding. For once, the waning of an agricultural activity, dairy farming, was met with a higher and better farming use—the breeding, training, and racing of standardbred and thoroughbred horses.

Upper Freehold remained sparsely settled into the 21st century. It grew around a number of small villages and towns, four of which are chapters for this book. Its two sections link town and country. A word on the sources: there are few published works on Allentown and fewer on the township. F. Dean Storms's 1965 *History of Allentown,* the borough's major work, draws heavily from newspaper and other previously published sources. Its principal newspaper source, the *Allentown Messenger,* extensively published local history in its early years from 1903. The 1979 Allentown Historic Sites Inventory places much information in a single document. This book drew from the three sources, including the traditional names of properties from the latter. However, considerable opportunity and need for primary work remain.

Although Upper Freehold Township has many fine old properties, some, such as the William Jackson Blacksmith Shop, are disintegrating. (See page 83.)

One

MAIN STREET: THE COMMERCIAL CORE

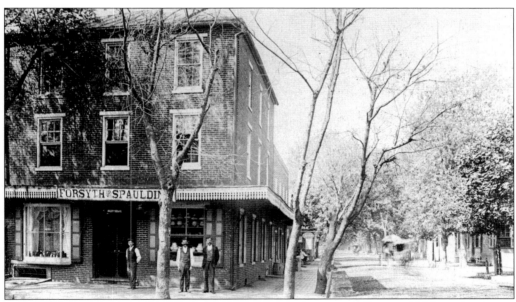

The Captain John Rogers Building was erected by the honorary officer in 1858 on the former site of Richard M. Stout's store, which had been vacant since the store's destruction by fire in 1844. The first tenant, Coward & Thompson, is described as "general merchants" (not an honorary title); the illustrated Forsyth & Spaulding firm began in 1883 and continued until 1900, when Forsyth withdrew. The three men shown in this c. 1890s photograph are, from left to right, Frank Fisk, Al Pitman, and Charles Spaulding. (Courtesy of G. Richard and Frances Walter.)

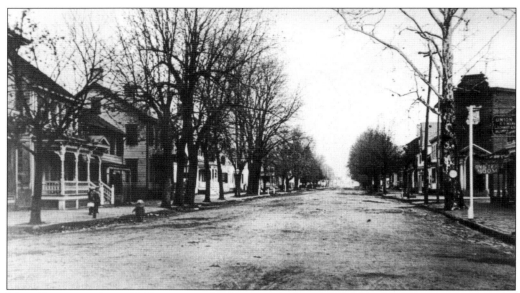

Main Street is seen *c*. 1908 in a view looking north from Church Street. The new bank (page 15) is on the right, behind the hotel's Oyster Room sign. The building on the left, 8 North Main Street, was a house of uncertain origin (perhaps *c*. 1840s, as is often ascribed to it, or earlier). It had been a store and office prior to its purchase by the borough in 1978 for use as municipal offices. It may be hardly recognizable, since the first floor was later clad with a brick facing. (Collection of Glenn Vogel.)

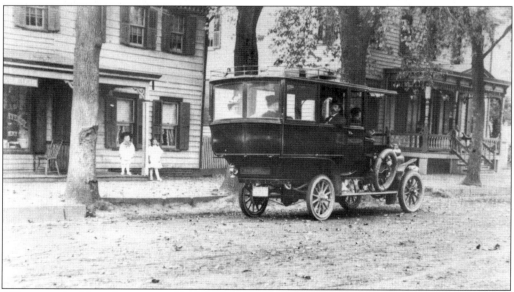

Allentown had long been served by horse-drawn stagecoaches (page 23), so it was newsworthy in 1908 when a White steam car was employed as an "auto stage." This-*c*. 1908 North Main Street view also provides a second glimpse of the borough hall (right) and 6 North Main Street. The latter was then an old house that had been moved behind Church Street prior to its replacement in 1933 by the brick Colonial Revival house on the site in 2001.

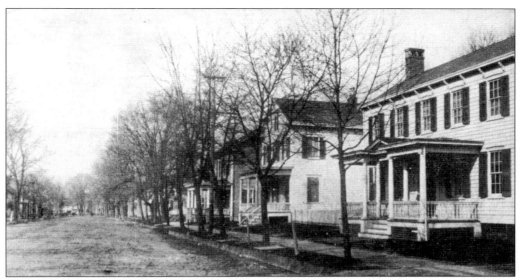

Main Street is viewed *c.* 1912 looking south from 36 North Main, which is the house on the right. It likely dates from the first half of the 19th century and is recognizable in 2001 despite stucco cladding. The building was once the Baptist parsonage. To its left are still-standing houses, Nos. 34 and 32, which obscure 30 and 28 North Main behind them. (Collection of Glenn Vogel.)

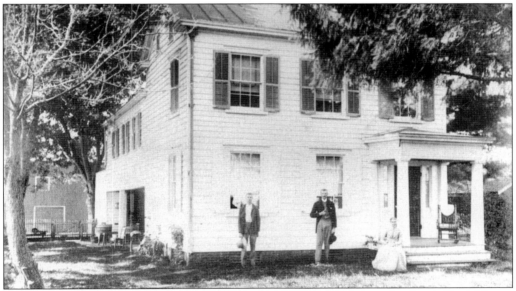

The Greek Revival dwelling at 18 North Main Street is known as the Jacob Ford House, perhaps for the *c.* 1830s builder. It was placed in front of an older house attributed to the late 18th century. Ford, a barrel maker, is believed to have had his shop in the building in the left background. The picture, from the Gordon collection, shows members of that family, presumably late-19th-century owners. The house has changed little, except for the addition of drains, an exterior lamp, and the inevitable porch rail, the latter omnipresent evidence of how contemporary building codes and historic preservation often clash. (Collection of the Allentown-Upper Freehold Historical Society.)

This Main Street image, looking south from Church Street, provides a good view of the east side of the street, which is underrepresented in historical collections. The small, 19th-century structure under the mansard, known as the E.I. Bills house at No. 7, is affixed to the larger structure. The adjacent front-gabled No. 9 is the M. Coward House, which long housed a shop; the double house next to it at No. 13 also has a retail background. Note the details, including the gas lamp on the right and the tollbooth on the left. Main Street, part of the original York Road, has a past, albeit an obscure one, as a toll road.

John Rogers built the pair of two bay stores at 4 and 6 North Main Street adjacent to the corner c. 1860, shortly after completing the corner building (page 9). A longtime tenant of No. 4 was the Allentown Candy Kitchen, pictured on page 18. (See page 17 for a closer view of the flat-roofed buildings at 8–10 South Main Street.) The side-gabled W. Bunting Building at No. 12 was a 19th-century residence (page 13), which was converted to a carriage shop and, in 1919, to an automobile showroom. Auto dealer Wyckoff Hendrickson advertised his opening in a "modern building," suggesting that year as the one of its remodeling. It has been the post office since the 1950s (page 22). (Collection of Glenn Vogel.)

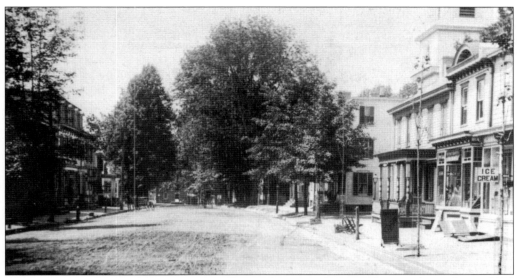

The later post office building, No. 12, is pictured as a residence with a porch on this *c.* 1908 postcard. Note the appealing cornice crest on adjacent No. 10. The extension of its open storefront beyond the building line looks fitting. The Baptist church is pictured individually on page 44, or in the streetscape on page 22. The mill is in the background.

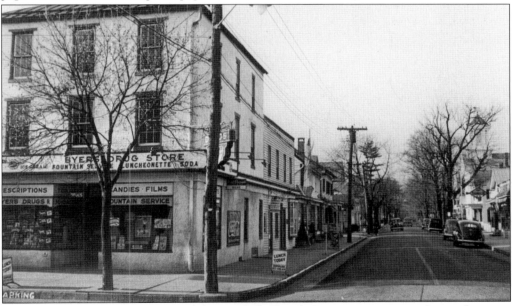

The store on the southwest corner of Main and Church Streets was converted to a pharmacy when purchased in 1937 by A. Larry Byer, who moved from his place at No. 10. He sold the business in 1965 to G. Richard Walter, the owner in 2001. Compare the front windows with the page 9 image; the latter served as a model for restoration after the storefront was damaged by a car *c.* 1985. The second story was used at times in the 19th century as an armory and drill room. The third floor was a later addition, extended across the two buildings seen opposite, and was occupied as a public hall. The canopied store on the right on Church Street was the site of the Deerslayers, pictured on page 53. (Collection of Glenn Vogel.)

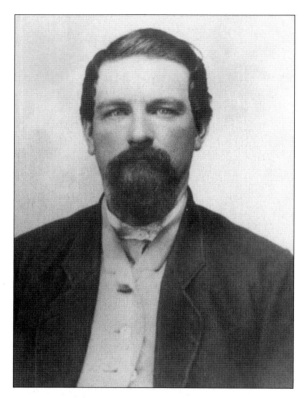

The Farmers National Bank of Allentown was chartered in 1886, opening that June 7 at 29 North Main Street. Its home was in an early-19th-century structure originally known as the Beatty House and later as the David McKean Warehouse. George H. Vanderbeek, pictured, was one of the key organizers (along with Gilbert H. Worden and David M. Bunting) and was the bank's first president, serving until his death in 1904. (Collection of the Allentown-Upper Freehold Historical Society.)

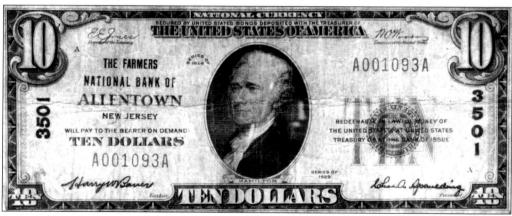

National banks were permitted to overprint currency with their own names, a practice that ended in the 1930s. Many remain in collectors' hands; the collection of such notes is an active branch of numismatics. Collectors often display them with postcards of the bank. The *Allentown Messenger* series published cards of both the exterior and interior of Farmers. (Collection of the Allentown-Upper Freehold Historical Society.)

In 1905, Farmers National Bank cleared the triangular plot at the northeast corner of Main Street and Waker Avenue of two houses and hired Trenton architect W.A. Poland to design this artful Colonial Revival bank. The new building opened in March 1906; the dedication ceremony included religious services. Note the classical, pedimented doorframe and the window lintels. The first floor's rounded arches reflect the Commercial Italianate style that was then waning after decades of popularity. The image was taken shortly after the completion of the building; the clock that is still mounted on the west elevation had not yet been installed. The Farmers National Bank moved to new headquarters at 40 North Main Street in February 1967 and was merged into the Central Jersey Bank & Trust Company in March 1963. The building was used as shops for years and is now an office. Little is changed; even the vault is used for storage.

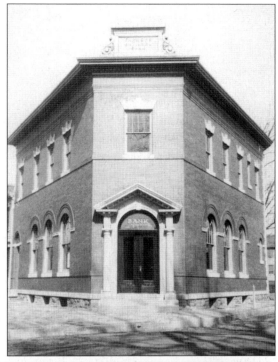

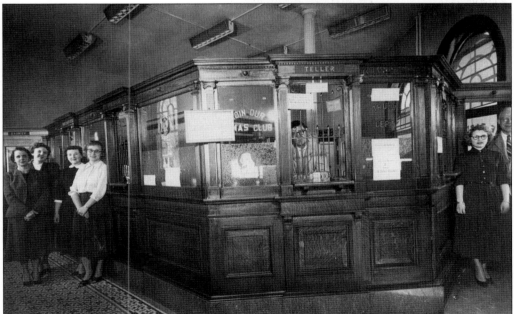

Not much changed in the bank's interior other than the lights and the mounting of paper signs. Comparing the original teller's cage with the post-1960s open designs is a reminder of when banks had greater consciousness of security rather than friendliness. The c. 1950s staff includes, from left to right, Beulah Tindall, Rosalie Bodine, Louise Steelman, Catherine Rue, Donald Peppler, Jacqueline Peppler, and Alvin Hendrickson.

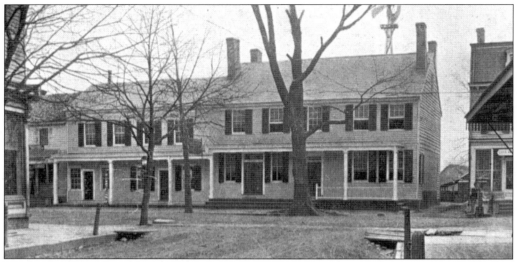

The Union Hotel dates from the last quarter of the 18th century, originating as Cunningham's. The first section was the south building, with the four interior chimneys, which one suspects may have been built in two parts. The northern section was added in 1872. The hotel was a true community center and included at various times a court, law office, polling place, billiard hall, bar, as well as a barbershop, an occupancy indicated by the pole on the left. Only the front left chimney remains. The entrances have also been altered. The windmill was destroyed in January 1909. The former hotel, pictured on a c. 1907 *Allentown Messenger* postcard, still serves long-term residents, but it is best known for its grade-level liquor store, left, and restaurant, right.

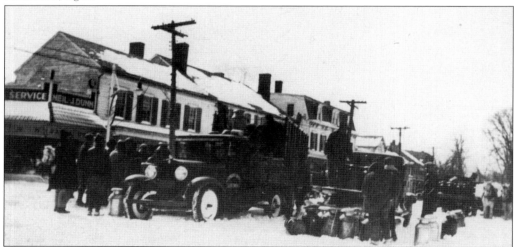

Many men are pictured on February 27, 1934, handling milk cans in a snow scene photographed in front of the hotel. The milk was brought to town on horse-drawn sleighs for transfer to trucks that then took it to market. The small, northernmost section in the top image was replaced by stores pictured here, a structure that has been removed for the service station now on the southeast corner of Main Street and Waker Avenue. The mansard belongs to the George Middleton Building at 3–5 South Main Street, a likely c. 1870s addition to an older building, one erected in two parts. (Collection of the Allentown-Upper Freehold Historical Society.)

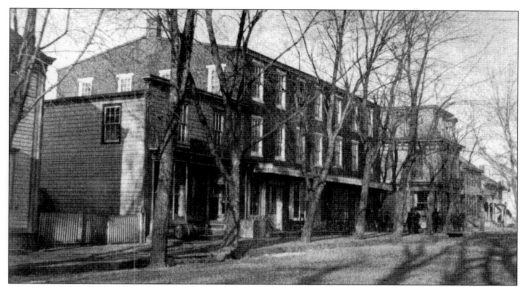

These two views, taken about 40 years apart, reflect subtle change on the South Main Street block. The street appears to have been widened in the 1890s, accounting for mature trees in the roadway and the newly planted trees in the c. 1908 image on the top of page 13. The three-story buildings are the three Rogers stores; No. 8 is adjacent underneath them. This store is believed to date from the first quarter of the 19th century. The gap to its left lends support to the c. 1900 construction date for No. 10; the cornice crest shown on the top of page 13 is stylistically consistent with that period.

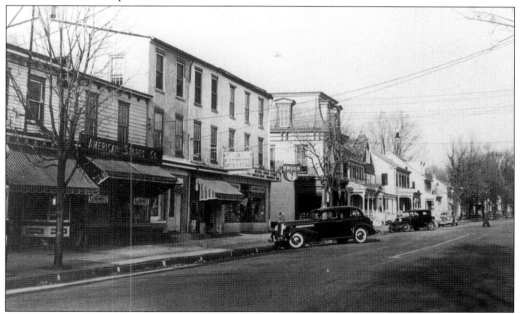

The gas pump belongs to the auto dealership described on page 22. No. 10, on the far left, had lost its cornice crest by the time of this 1938 image. No. 8 was an American Store, a chain food store and forerunner to the Acme. It was operated by Amos Byard from the 1930s into the 1960s. The mansard at 2 North Main was removed by fire. (Collection of Glenn Vogel.)

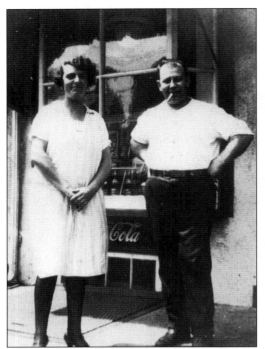

Chris and Eva Theoharis began business in February 1920 at the Church Street side of the building at the southwest corner of Main Street (page 9). They moved to 4 South Main Street in the spring of 1922 in the premises once occupied by the Curtis Restaurant, serving ice cream and light lunches and selling three varieties of chocolates. They advertised using only their surname, but the place became renowned as the Allentown Candy Kitchen. Chris emigrated from Greece c. 1910, returned for the Balkan war, and came back to the United States to serve in the American forces during World War I. The place became a popular hangout for local farmers and an active venue for political discourse. Theoharis also served dinners to teachers at 25¢ per meal, recalled his daughter Mary.

Hand-dipped chocolates were their specialty, as were obviously decorated eggs at Easter, no doubt what Johnny in the background was calling for. Chris died in 1970, and Eva maintained the business into the late 1970s. She owned the building and the adjacent No. 6, where she lived. Eva died in 1988.

Malt Extract.

A NICE FOOD TONIC!

A good remedy for all nervous disorders, insomnia,
stomach troubles, and general debility.

20c. per bottle.

Carslake Pharmacy.

Hopewell Dainties. Good Cigars.

T. R. Stephan,

Main Street. Phone 160. ALLENTOWN, N. J.

Those early tonics were very good for a noteworthy reason, which was not advertised: their alcohol content. But why mention it? There was no need for those who knew, and why deter the abstinence market? T.R. Stephan advertised his malt extract in 1913; he became manager of Carslake Pharmacy later that year.

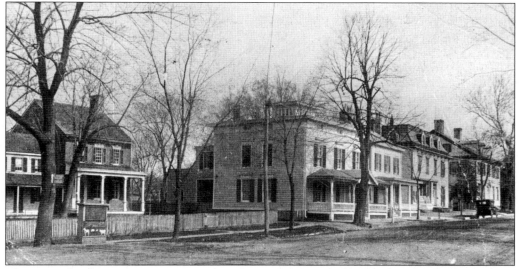

The west side of Main Street is pictured on this c. 1912 postcard looking north. The perspective in front of the Mill House, on the left and on page 32, provides a clear view of the c. 1860 Italianate J.C. Vanderbeek House adjacent at No. 36. The house is unchanged in 2001, but the cupola and rear additions are not often seen from closely built Main Street. Next to it is a traditional c. 1840 house, locally known as the Stout and Fish General Store, which contains a retail occupant. The mansard roof denotes No. 30, the former Messenger Building, also seen on page 23.

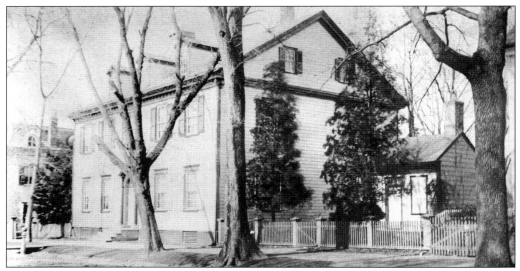

The John Imlay House, at 28 South Main Street, is universally referred to as the "Mansion" for the good reason that it is one of the finest Georgian houses in New Jersey. Imlay, a successful Revolutionary War–era Philadelphia merchant, returned to the area of his mid-17th-century birth *c.* 1790 to build his retirement home. The structure, a masterwork in every detail, was his home until his 1813 death; his son William then occupied it until 1880. This early-20th-century photograph shows the north elevation, to which is affixed an early office wing, which remains an office. Fire escapes have been added here to the main house, a change required by a 1930s occupant, Dr. Walter Farmer's hospital. (Collection of the Allentown-Upper Freehold Historical Society.)

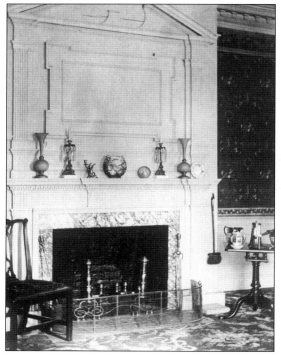

Eleven of the 15 rooms contained a fireplace. The richly carved parlor mantel of the Imlay mansion is its outstanding interior architectural feature. In addition, here was formerly hung the house's decorative arts highlight, wallpaper purchased in London in 1794, a variety that was cut and affixed in small squares. The paper was acquired by the Metropolitan Museum of Art in the late 1920s for installation on the wall of their American Wing's Haverhill Room. The parlor was later Dr. Farmer's office and is now home to the shop Necessities for the Heart. (Collection of the Allentown-Upper Freehold Historical Society.)

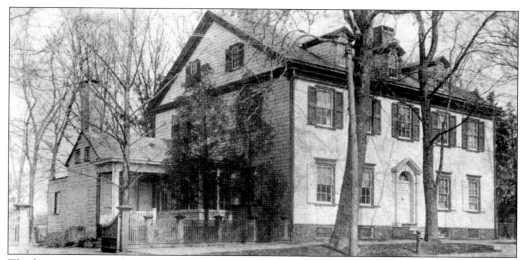

The house is pictured on its southeast corner, depicting a likely service entrance that is now a shop. Three courses of brick are believed to surround a stone foundation. The house was later occupied by William Imlay's son-in-law Jonathan Fisk, of Trenton, and then by his widow, Mary, accounting for the description "Fisk Mansion" on this c. 1912 postcard. One of her relatives, Mary Emma Gordon, occupied it next, operating a boardinghouse until her 1935 death. The June 1936 estate sale dispersed Gordon's significant Americana collection. Farmer bought the realty from her estate. His hospital was formally dedicated on Sunday, June 6, 1937. (Collection of Glenn Vogel.)

The room-size hall, typical of large, 18th-century houses, is pictured here. The richly detailed stairs, according to Imlay family tradition, took a master carpenter six months to build. Each landing is unsupported. The balustrades are mahogany, and a scroll-saw ornament is carved under each riser. The hall, which leads to a room in each of its corners, was a waiting room during the hospital years. A medical ward was in the front south room. A maternity ward was behind Dr. Farmer's office; the office wing was used as a nursery. The maternity facility was later located next door at No. 30 (page 23) prior to its early closing. (Collection of the Allentown-Upper Freehold Historical Society.)

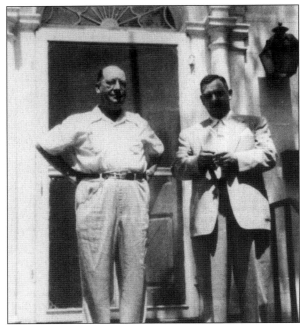

Dr. Farmer (left), a singular personality, was a surgeon and liked to utilize his specialty. It has been said that most of his patients were from out of town. His facility remained open as a hospital until October 1957 and for many years afterward was Dr. Farmer's "private clinic." He died in 1984. Farmer is pictured with Dr. Medard A. Selecky, a University of Pennsylvania Medical School graduate, who became associated with Farmer's medical practice in 1948.

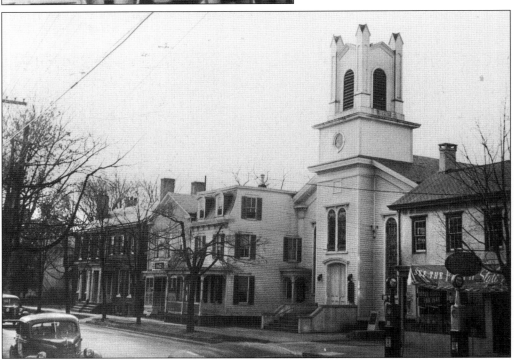

A partial view of the Wyckoff Hendrickson Ford dealership at No. 12 is pictured in 1938 on the right. The front-gabled building at No. 18, to the left of the Baptist church and parsonage (page 44), is the Brick Store, the oldest retail building in town, erected by Ephraim Robbins for Robert De Bow in 1815. The brick houses at 20 and 22 are also on the top of the next page. (Collection of Glenn Vogel.)

The Federal-style, brick double house at 20 and 22 (left) South Main Street was built *c.* 1810 by Ephraim Robbins for Robert De Bow. The buildings' varied history includes use as a school *c.* 1829 at No. 20, taught by Mary and Catherine Beatty. This part of the building contained the Emmons Lunch Room a century later. There were also a number of retail occupancies. Two Newell women occupied each section for many years. Their erecting of the porch and bay-windowed, gabled addition in 1907 was hailed then as a major improvement. Before the end of the century, it was an inappropriate excrescence. The house stands little changed in 2001. (Collection of Glenn Vogel.)

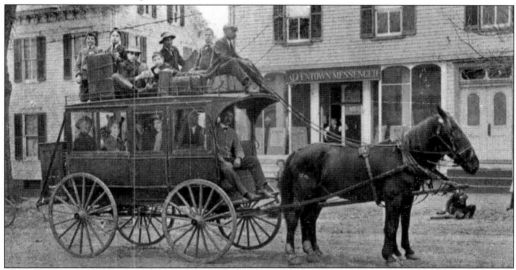

Many stagecoach routes passed through Allentown, along its major north-south and east-west roads, during the Colonial era. Daniel C. Jones established a local daily mail and stage run to Bordentown in the mid-19th century. Edward Dilatush was the latest of a succession of Allentown stage owners at the time of this 1907 *Allentown Messenger* illustration, which pictures Charles Joiner, who was for many years Allentown's borough clerk, in the doorway of the paper's headquarters. George Johnson is the driver. The storefront, at 30 South Main, was later enclosed, leaving no trace of this look. The building became Dr. Farmer's maternity wing in 1944; it is apartment residences in 2001.

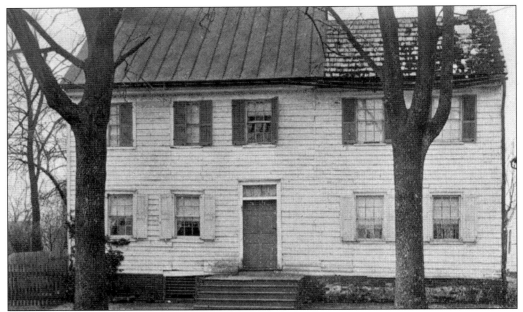

This residence, formerly at 26 South Main Street, was pictured in the *Allentown Messenger* on June 20, 1907, with a nostalgic account of old local memories and how changes were then planned for the "oldest house in Allentown." To answer the question why Allentown has so few 18th-century buildings, the town was probably "spoiled" by success, replacing most older properties in the prosperous 19th century when preservation only meant canning in the kitchen. The town was too small and successful to retain "obsolete" buildings. The place survived for about 35 more years until replaced by the last of the Messenger buildings, a place now occupied as a store.

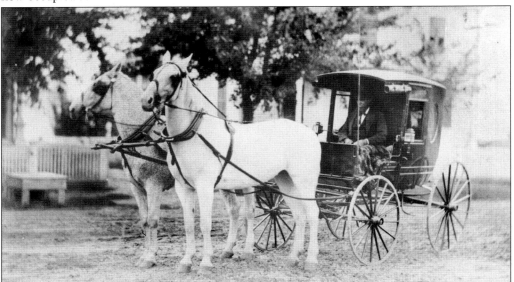

A fine team and an unidentified driver are captured in this rare tintype from the latter 19th century. The scene is in front of the Imlay Mansion. (Collection of the Allentown-Upper Freehold Historical Society.)

Two

THE MILL AND
POND AREA

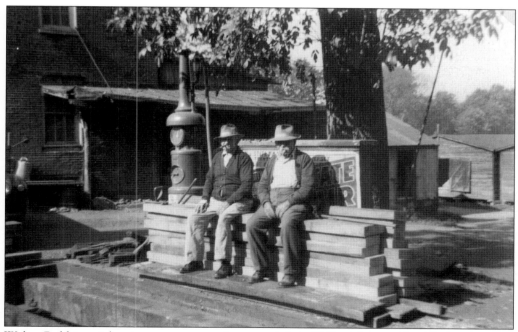

Walter Robbins, right, sits atop construction materials in 1945 with an unidentified companion during the building of a new mill scale. Having retired from their real jobs, they became self-appointed inspectors, who made sure things were done the right way. The project replaced the five-ton scale installed in 1907.

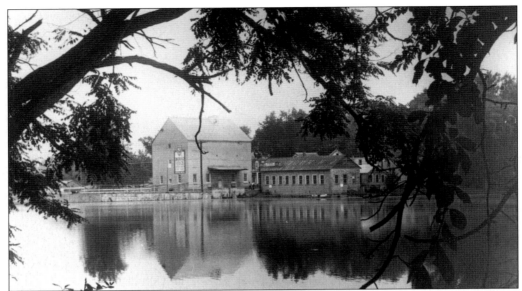

Allentown dates its founding from Nathan Allen's substantial 1706 land purchases, which included 110 acres on Doctors Creek. Not long thereafter, Allen built a gristmill at the future Allentown, which was initially known as "Allen's Town" (long before there was a U.S. Board on Geographic Names to rule that there are no apostrophes in place names). His mill was located about 25 yards north of the present structure; he also built a fulling mill on the site of the pictured gristmill. (Rutgers Special Collections and University Archives.)

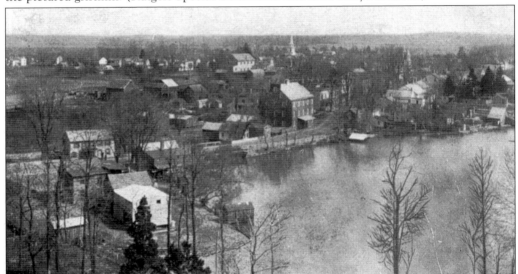

The steeple of the Presbyterian church on High Street provided a great vantage for an "aerial" view of town. The mill, Allentown's most prominent landmark, is evident in the middle of the picture. The steeple above it is of the Methodist church on Church Street; the light point near the right is the Baptist church on Main Street. The Grange Hall is the larger building to the left rear of the mill, and the former firehouse is the small building in the left foreground of the mill. The blacksmith and wheelwright shops are the two closer buildings on the left. The often reproduced image is a *c.* 1907 *Allentown Messenger* postcard.

26

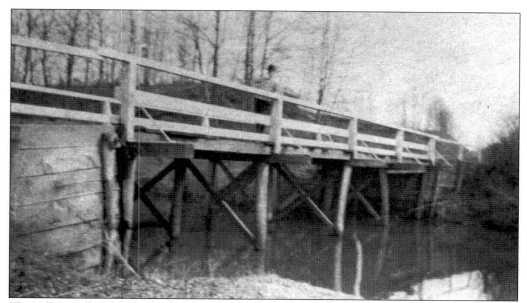

The Allen mill was located about 25 yards north of the present structure, and Doctors Creek was dammed about 1,200 feet upstream from the present dam. This bridge spanned Doctors Creek at the southern end of the former pond, about 25 feet east of the present bridge. It had been removed by 1855, creating special interest in the history of the image. Alice Wikoff provided the author a cyanotype print, noting it was a copy made from a photograph printed from a glass plate.

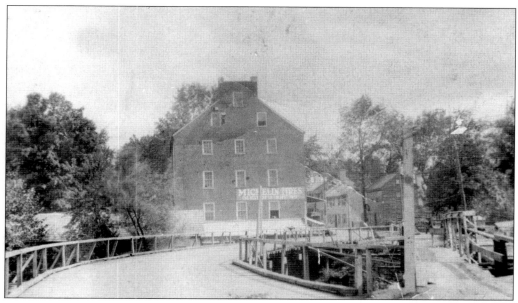

Main Street's course once ran straight past the millpond, but it took a curve, as indicated above, later when a wider bridge was erected in 1921. The contractor was Thompson & Matthews of Red Bank. The covered bridge in the left background went over the millrace to the back of the mill.

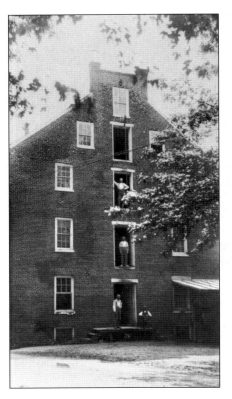

Abel Cafferty bought the mill property in 1845 from Richard Bruere, who had owned it for 10 years. They were two in a long succession of owners; then, the mill structure was reportedly Allen's original (although, if so, it had been altered over its long existence). A mill tradition was the writing on the wall of various events, typically news. Abel's son Howell left an extraordinary account of the new mill's construction, writing to his brother John that "Uncle Nuch [Enoch Cafferty] had charge of the brick work when the mill was built and a millwright by the name of John Lesly built the inside and put in machinery and built the old wooden water wheel. The bricks for the mill was made in the field out back of the apple orchard. . . . Pop had the new and the old mill running at the same time and then he tore the old mill down and built the mules stable out of it." The first grist was ground on October 20, 1855. The bricks totaled a reported 300,000. Sitting on the platform in this c. 1900 view is Henry A. Ford, who bought the mill in 1895. Standing next to him is his head miller and a future owner, John R. Conine. Their sons, Evans H. Ford and William B. Conine, stand at the third and second floors, respectively.

Ford replaced the operating equipment c. 1902. An enumeration of his order with Allis-Chalmers helps depict mill operation, although this equipment may not be a complete listing. The fourth floor contained a wheat brush scourer, polisher-rolling screen, and elevator head, along with a receiving separator. On the third floor were a bolter, flour dresser, bran reel, dust collector, grain bins, and miscellaneous equipment. The second floor was finished with a middlings purifier, corn and cob mill, flour and grain bins, and stock hoppers. The first, or grinding, floor was equipped with a number of rolls, a packer, a pair of underrunner burrs for cracking corn, runner stones for chopping feed, a mill for cob meal, a four-hole sandwich corn-sheller, hopper scales, feed bins, and the office. By 1918, the mill was the last in Monmouth County to be powered by water.

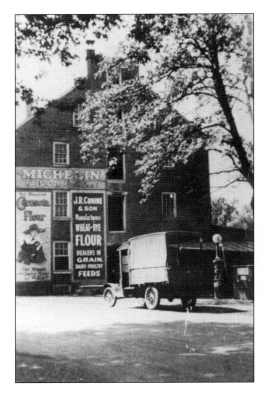

John D. Conine, left, is pictured *c.* 1910 with Amos "Pickles" Robbins. Conine's father, John R., was born in Howell, was educated in Freehold, and developed an early flair for mechanical operations, working as carpenter, blacksmith, machinist, or miller (his life's work). He began with New Bargain Mills in Howell Township in 1874, later working in mills at Fairfield, Francis Mills, Red Valley, Colts Neck, and Imlaystown, moving from the latter to Allentown *c.* 1895. Conine bought a partial interest in the Allentown mill in 1915 and operated it in conjunction with his son John D., who sold the mill to Frank Drialo in 1952. Drialo electrified the mill but was not successful, losing the mill in a 1965 sheriff's sale forced by his mortgagee, Peter Sadley. Sadley sold it later that year to William Chamberlin.

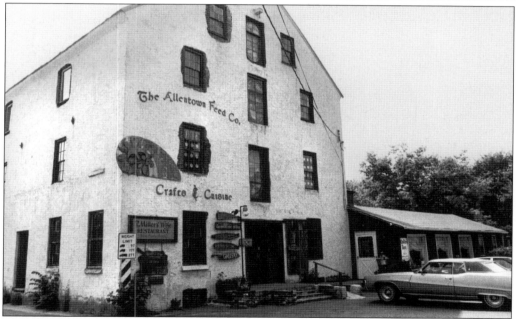

Chamberlin converted the mill to a restaurant and gift shop. The bricks were painted white, the now-peeling covering looking worse in 2001 than in this 1983 picture. There is no feed sold, the "Allentown Feed Company" designation being for trade name purposes only. The building's appearance remains the same, except for a different restaurant and a new 10-ton weight limit sign for the bridge, which is scheduled to be replaced.

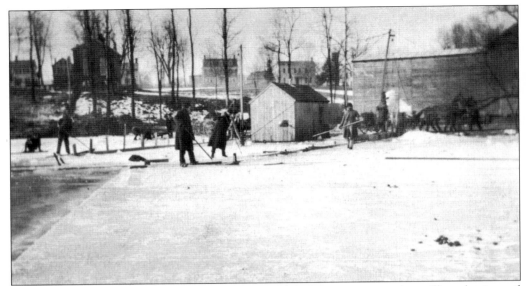

Buildings on High Street provide the background for ice cutting on the millpond, pictured *c.* 1900. Elias Rogers was a major operative in the industry in the late 19th century, until supplanted by Hillis Jones, who used a gasoline-powered engine, apparently the tall object in front of the building on the right, to hoist the heavy blocks. The workers appear to be guiding the blocks along a sluiceway cut in the ice.

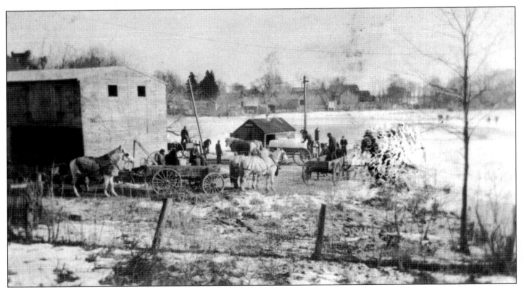

The two-wagon loading operation involved a slack rope on the empty side picking up ice from the pond while the other side was hoisting a cake into a wagon. The ice needed to be at least 5 to 7 inches thick to begin cutting, but 10-inch-thick cakes were taken when depth permitted. The size of cakes varied with handling equipment and storage capabilities. The cakes ranged from 22 by 22 inches to 22 by 26 after the gas engine facilitated the operation, to 24 by 30 by *c.* 1915. The harvest was stored in the creamery icehouse. The rears of buildings on the east side of Main Street are pictured *c.* 1900 in the background.

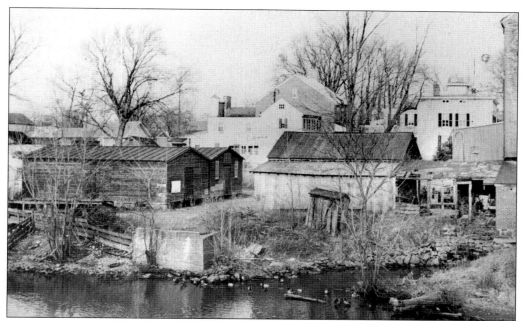

The buildings supporting the mill operation are pictured in two 1938 views; the corner of the mill at the far right provides place orientation. The Mill House, 38–40 South Main Street (page 32), is the two-part structure under the tree in the center. The storage building under it was moved adjacent to the two narrow, front-gabled buildings and was later taken away or razed. (Collection of Glenn Vogel.)

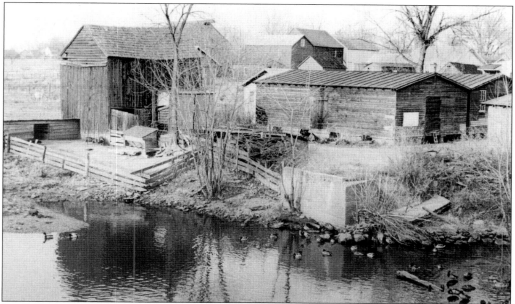

The views are northwest from the bridge. The masonry block in the foreground was a foundation for the bridge pictured on the bottom of page 27 that connected the mill and storage buildings. The two long feed buildings survive, but the rest are gone. (Collection of Glenn Vogel.)

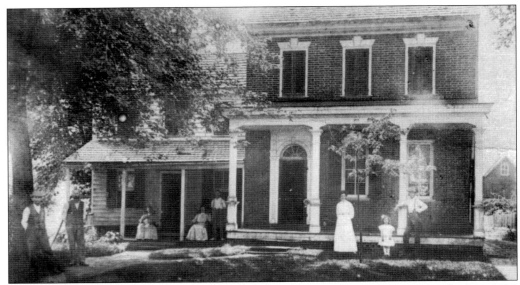

The brick, Federal-style section of the Mill House, at 38 South Main Street, was built *c.* 1800 in front of an older frame house, which now makes up a rear ell. Its bricks were made from the same clay pit that was the source of the mill's bricks; the name stems from the house's former attachment to the mill property. Notice the fine door surround and fanlight, along with the second-story lintels. Two mill families are pictured *c.* 1915, the Evans Fords on the right and the John R. Conines in front of the frame section. The frame section was added at an unspecified later date, perhaps *c.* 1855, in conjunction with the mill replacement.

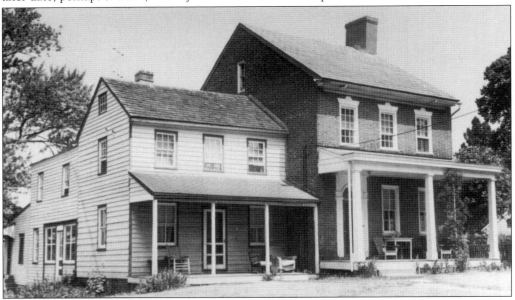

This Mill House picture, dated 1955, indicates little change. The building fell into neglect by *c.* 1970, was purchased by a developer, boarded-up, and threatened with destruction when it became a preservation issue. The frame section was demolished by a bulldozer on December 11, 1981, but the brick section remains. It stands in fine condition, its only significant change being the replacement of the full porch by a small entry porch.

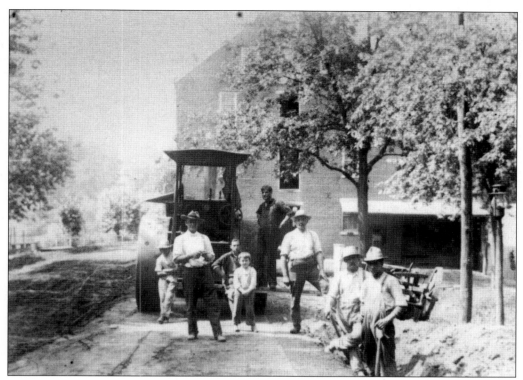

Main Street is pictured during its *c.* 1903 paving project. The mill is in the background.

John Dawes Conine (born in 1884), son of the first of the family's mill owners, is pictured *c.* 1940s in front of the store adjacent to his auto repair shop (pictured on the next page). The store was opened to sell automobile parts but also sold a few food items such as candy, soda, and bread. The window decals also indicate a cigar trade, and a second pump dispensed kerosene. Conine sharpened skates, and the place became a winter hangout for children who enjoyed banter with Conine. He died on August 4, 1964; the place was demolished the next year, the grounds becoming the yard for the adjacent house.

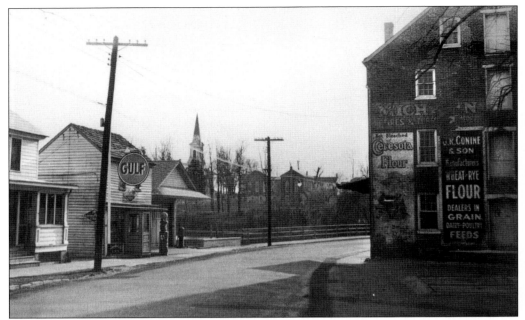

The Conine mill signs were painted *c.* 1920. Ceresota was a type of flour from the milling process. The mill operated into the 1940s; one route was maintained into Trenton that sold to local bakeries. The view, looking southwest toward High Street, shows the Presbyterian steeple and, to its right, the Presbyterian education building. (Collection of Glenn Vogel.)

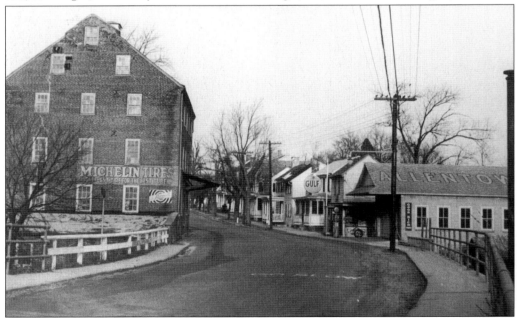

The painted roof of John D. Conine's auto repair shop left visitors with no doubt where they were. Behind it, pictured in 1938, is the store on the preceding page, followed by a row of still-intact houses, beginning with No. 51, home of Alice Ely Wikoff, who furnished many of this book's finest images. (Collection of Glenn Vogel.)

Three

SOUTH MAIN STREET

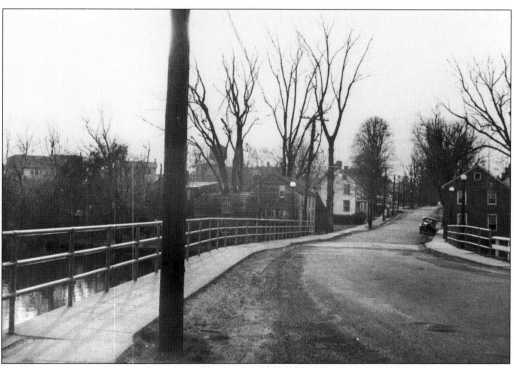

The lots on South Main Street southwest of the bridge are larger, and the houses reflect a variety of architectural styles from throughout the 19th century into the 20th. This view, around the bend from that on top of the opposite page, is the last of the 1938 series that demonstrates how one day's group of street scenes is another era's historical documentation. The house on the right was demolished *c.* 1950s and replaced with another. The house on the left was once quarters for mill workers. It was demolished *c.* 1960s; its lot is now part of Sensi Park. (Collection of Glenn Vogel.)

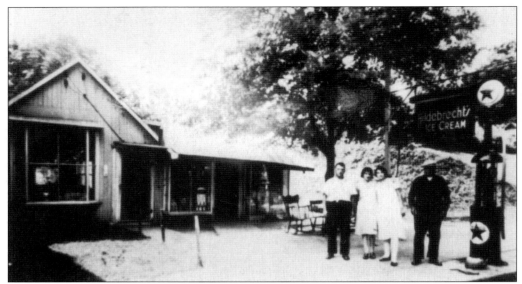

Pedro Sensi, an Italian immigrant known as Pete, is pictured c. 1930s in front of his store; the others are unidentified. The front-gabled section was his shoe-repair business; the section to the right was a grocery, added c. 1930s. The market was located on the east side of Main Street, a couple hundred yards or so south of the bridge. His son took over the business and also served a number of civic and community organizations. The younger Sensi died in 1995; the borough honored him by renaming Mill Pond Park Pedro Sensi Park in 1998.

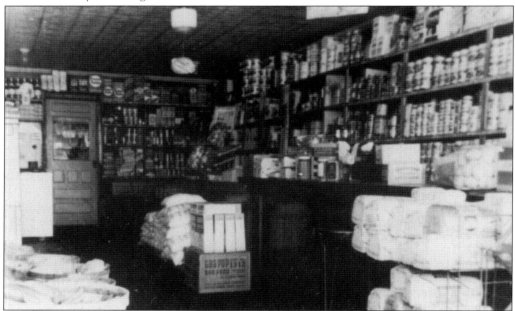

The interior of Sensi's market is pictured in the 1930s, a time when Alice Wikoff remembers each half of an unwrapped double loaf of bread cost a nickel. (Younger readers probably cannot remember a nickel useful for anything, but the author dates himself by recalling the nickel candy bar.) The market building still stands, although it is unrecognizable, as a major addition obscuring the early structure was built close to the street.

The location of the blacksmith and wheelwright shops on the east side of South Main Street adjacent to the millpond can be seen from the air on page 26. The blacksmith shop survived into the late 1940s, near the time of this image, when the last practitioners were Gary Bird and Clarence Morris. It became a child's hangout, the smithy making the youngsters rings from horseshoe nails and providing waste wood for winter bonfires. Sensi Park is on the site in 2001.

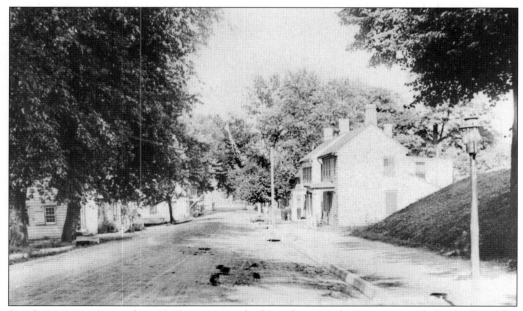

South Main is pictured c. 1910 in a view looking from High Street toward the bridge. The grounds of the Newell House are on the right, in front of two still-standing houses that were apparently later occupied as stores.

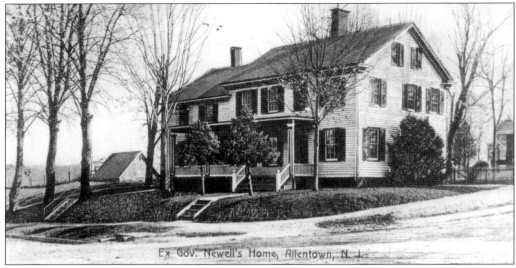

Dr. Thomas West Montgomery began 81 South Main Street at the northeast corner of High Street *c.* 1793, a house known by the owner William A. Newell, who bought it in 1844. Newell, a physician and one of Allentown's most distinguished citizens, founded the Life Saving Service in the 1840s, served three years as governor of New Jersey beginning in January 1857, and was elected in 1864 to his single term in Congress. Newell was later the territorial governor of Washington. The house is little changed, other than its chimneys and the addition of vinyl siding. The garage on the left is gone. A glimpse of the Presbyterian church is seen on the right on this *c.* 1910 postcard. (Collection of John Rhody.)

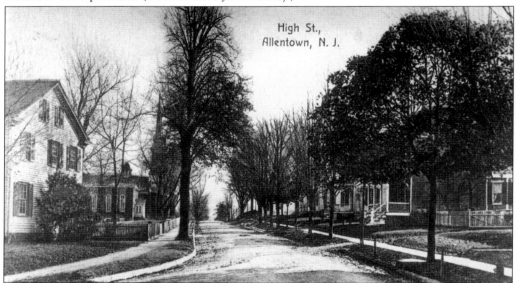

High Street, which is also County Route 539, is shown in a view looking east from Main Street. The south elevation of the Newell house is on the left. The Presbyterian church and educational building are behind it. On the right is 5 High Street. It appears that the house—home of local historical society president John Fabiano and his wife, Barbara—may date from the Greek Revival period, perhaps *c.* 1840s. It was enlarged and remodeled and now possesses the look and character of a Queen Anne–style house. (Collection of Glenn Vogel.)

This simple, Four Square–style house was erected by Charles D. Knowles in 1925 at 111 South Main Street. It is an example of later additions amidst a street of older houses. The house stands little changed, although its awnings are gone and the clapboard first floor is now vinyl sided. The place retains its shingled upper story and the center stained-glass window. This perspective, if viewed in 2001, shows the borough's water tower behind the house. (Collection of the Allentown-Upper Freehold Historical Society.)

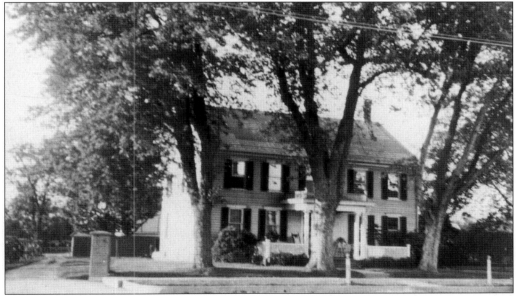

The George Ford House, named for its apparent builder, is located at 142 South Main Street where the Allentown-Yardville Road splits from Main Street (page 51). It was built in two sections—the three bays to the left, or south that make up the earlier part, which is attributed to the first quarter of the 19th century. The house was also the onetime home to Josiah Robbins (page 56), inventor of the potato planter. The old chimneys, porch, and large trees are gone, but the house is readily recognizable from this 1929 photograph. (Rutgers Special Collections and University Archives.)

The two fine Italianate houses opposite one another on the southern stem of Main Street were built by two generations of the same family. They possess significant decorative differences, although they are stylistically similar and are sometimes called twin homes. Aaron and Elizabeth Robbins built 114 South Main Street, perhaps c. 1850. The five-bay house has a low-pitched hipped roof, octagonal windows in the attic half-story, and a rectangular cupola. The north elevation shows an apparent original interior chimney; the one on the left is a replacement. The former residence has been occupied as the Peppler Funeral Home since 1941.

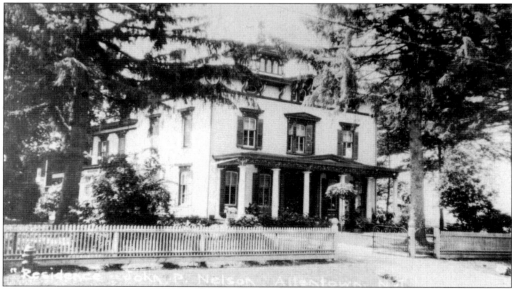

Charles Meirs and his wife, Anna (daughter of Aaron and Elizabeth), built the house across the street from them at 123 South Main Street, perhaps in the late 1850s. It has a flat roof and richer decorative details. Dr. Walter D. Farmer was a noteworthy 20th-century owner. The property is named Tree Haven, although the tall trees in this c. 1915 photograph are gone. (Collection of Glenn Vogel.)

Four

MIND AND SPIRIT

The choir of the Methodist church is pictured posing in front of its organ in 1940. They are, from left to right, as follows: (front row) Ena Mae Anderson, Alice Ely, Carolyn Burtis, Betty Anderson, Dorothy Laird, Mary Ellen Williams (at the lectern), another Laird girl, Marion Conine, Laura Burtis, a Leming girl, and Marie Leming; (back row) George Tantum, Madeline Merritt, Sara Stanhope, Louise Sprague, choir director Esther Messler, an unidentified Oakerson, Betty Ann Snyder, and Amos Stanhope.

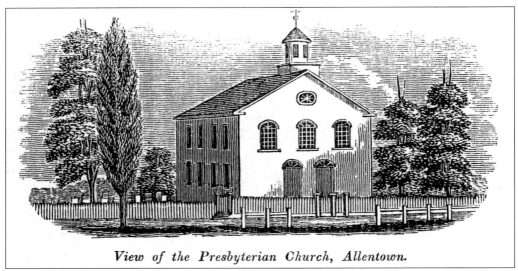

View of the Presbyterian Church, Allentown.

The Allentown Presbyterian Church was founded in 1720, several years after Presbyterianism was first preached in the area, when a small meetinghouse was built on a back lot on South Main Street. An acre was secured "on the hill" in 1744, and this brick meetinghouse was built in 1756 during the pastorship of Charles McKnight (1744–1766). He later served in Matawan, saw his church burned during the Revolutionary War, was imprisoned, and died on January 1, 1778, from the effects of his imprisonment. This woodcut was first published 1844 in Barber & Howe's *Historical Collections of New Jersey*. The building was demolished in 1837.

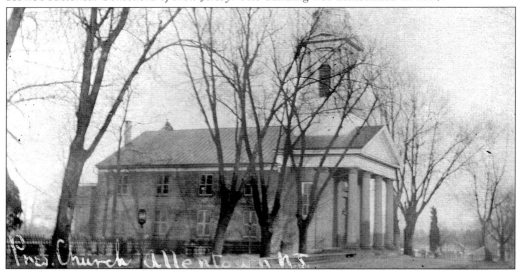

Tradition claims the new church was erected in 1837 from materials salvaged from the old church. The building did not take its present and pictured appearance until 1856, when the steeple and Greek Revival portico were built. The cemetery behind and east of the church is the final resting place of many Allentown notables. This *c.* 1910 photographic postcard focuses on the west elevation and is one of many of the era by an unidentified photographer whose otherwise fine pictorial representation of the town is marred by prints lacking contrast. The steeple was later replaced, and changes were made to the building after the 1949 hurricane, including the addition of an organ chamber, pastor's study, and choir room.

The Greek Revival–style Presbyterian Academy was built in 1856 on a High Street lot west of the church on the site of an earlier education building erected prior to 1819. The building was remodeled in 1904 and expanded via the erection of a replica on its east in 1934. The door, as depicted in this undated image, was relocated left of its original location, and the cupola was removed. Although the school was church owned, many Allentown youth were taught there; one could say it had a *de facto* public education role. It ceased operation after the 1876 opening of the graded school on Main Street (page 46).

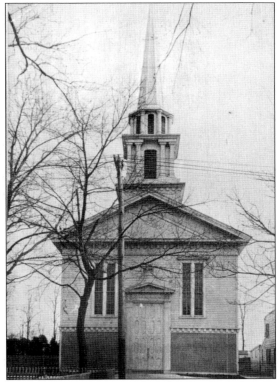

The Methodist Episcopal church in Allentown was formally organized in 1810, but Methodist worship in Allentown began *c.* 1795. Their first church was built in 1832 on the south side of Church Street at the later location of the African Methodist Episcopal church. The Methodists moved to their present location at 21 Church Street in 1832. The 40-by-60-foot edifice pictured on this *c.* 1910 postcard was erected by locally prominent builders Elias B. and Benjamin Rogers in 1859–1860 (architect unknown) and dedicated on February 20, 1860. The church has a new steeple. The safety of the pictured one was questioned in 1884, but its removal, neglected until it was near collapse, was not effected until February 24, 1913. The interior was modernized in the 1950s, and an education building was erected and attached to the rear of the church in the early 1960s.

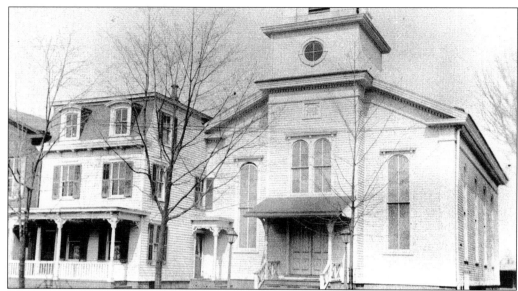

The First Baptist Church of Allentown was founded in 1874, mainly by members of the Hamilton Square Baptist Church. Members initially met above a store in a hall that had been built-out by locals Elias and Benjamin Rogers. The congregation later employed those contractors to erect this Vernacular Victorian edifice at 14 South Main Street on the site of the historic James Newell House. The cornerstone was laid on May 8, 1879, and the church occupied in December. They also built the Second Empire–style parsonage next door at No. 16. The image is a *c*. 1908 photographic postcard.

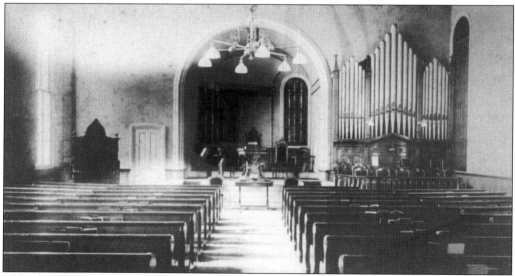

The Baptist church interior is pictured *c*. 1900. The building was damaged by fire in 1972 and sold to the Allentown Library Association a few years later, the Baptists having moved to 72 County Route 526. The library occupied the former parsonage, awaiting the funds and opportunity to remodel the church. They succeeded admirably, using a design by architect Thomas Kocubinski. The building stands as a superlative example of adaptive use. (Collection of the Allentown Library Association.)

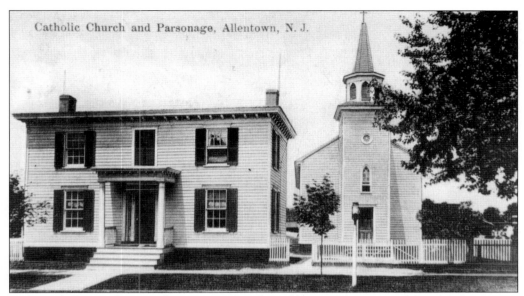

Catholic Church and Parsonage, Allentown, N. J.

Early Catholic worship in Allentown was conducted by visiting priests celebrating the mass in private homes. St. John's Church organized in 1869, the year the congregation purchased the former Episcopal church on Church Street (page 48). The pictured rectory, located on North Main Street, was bought in 1878, and the church, enlarged by St. John's, was moved adjacent to it in 1897. St. John's purchased land on South Main Street for a cemetery in 1885. The church is pictured c. 1907; the site is occupied by a bank in 2001.

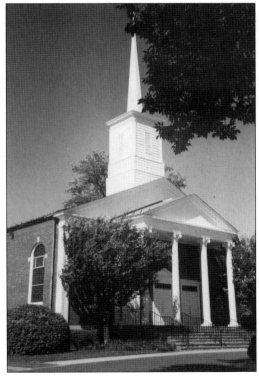

St. John's post–World War II growth was affected by the suburbanization of nearby communities. This led to their 1953 purchase of a 19.3-acre tract on the Allentown-Yardville Road in Upper Freehold Township, just beyond the borough border and near a number of growing Mercer County towns. Ground was broken for this edifice on October 17, 1954; the 1954 cornerstone was laid on May 22, 1955. The church was designed by English-born (1882) New Jersey architect Clement W. Fairweather, whose lengthy practice included numerous churches, private residences, and industrial structures. Bishop George W. Ahr was present for the dedication and celebration of the first mass on January 22, 1956. The building is pictured in 2001, its present steeple a replacement of the original, which had a domed top. The church's facility also consists of a Fairweather-designed rectory and an education building.

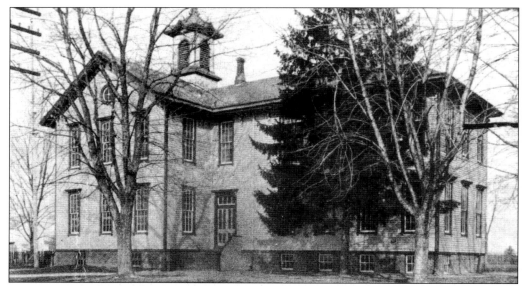

Allentown was late in providing universal free public education, using the inadequate Presbyterian Academy (page 43) as a quasi-public school. County superintendent Samuel Lockwood had to use the influence of former governor William A. Newell to convince the locals to provide a school. His efforts resulted in this fine building, erected in 1876 at 60 North Main Street, which provided a graded system, an advance at the time in public education. The building was vacated after the 1936 expansion of the High Street school, sold to Earle W. Hendrickson in 1937 and, in time, demolished. A house and new street are on its lot now.

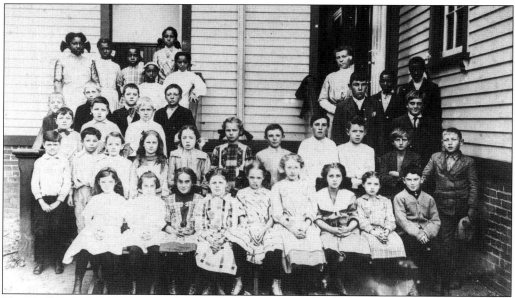

Elva Cafferty's third- and fourth-grade classes are pictured outside the school in 1914 or 1915. The students dressed well for the photographer. Notice how substantial the girls' shoes were, particularly impressive in later eras of ruinous female footwear. Look at how many children appear to mimic their teacher's expression, perhaps unconsciously. See, too, how racial separation extended even to posing practice.

46

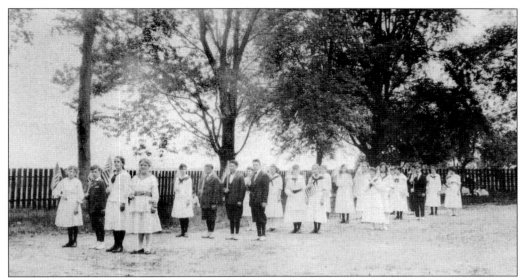

Allentown first awarded high school diplomas in 1891, prior to the formal organization of that level school, which came in 1910 when Allentown was registered as a two-year high school. This picture is labeled as the freshman and sophomore classes of 1917 or 1918, the only classes. Allentown graduates could study the third and fourth years in Trenton or other high schools. Voters approved the securing of a High Street site on the John Nelson estate for a new school in 1922. It was begun in January 1924, and its cornerstone was laid on March 31.

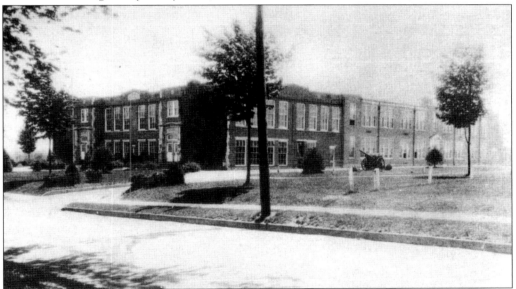

Henry A. Hill of Trenton was the architect for the modest Beaux-Arts design of the four-year high school, which opened for the fall 1924 academic year. The buff brick building, erected by general contractor William C. Ehret, also of Trenton, consists of the front half of the structure in this c. 1940 postcard. The rear half was designed by the P.L. Fowler Company of Trenton to match the original, which was erected with the aid of Works Progress Administration funds and completed in late 1936. The new section housed the eighth and high school grades. Students from the Main Street grammar school (page 46) moved into the 1924 building.

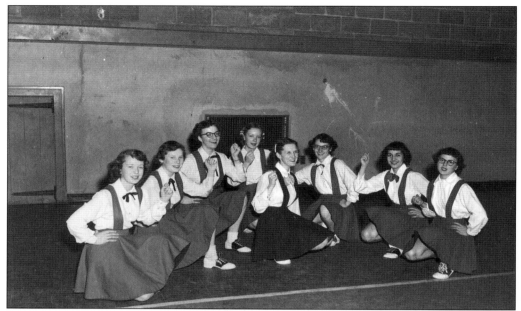

A new high school was built in an adjacent lot in the 1970s; the entire old high school building is now the Upper Freehold Regional Elementary School. The Allentown cheerleading squad is seen in the early 1950s. They are, from left to right, Shirley Dancer, Margie Roughan, Joan Faille, Shirley L. Rue, unidentified, Judith Anderson, and two unidentified girls.

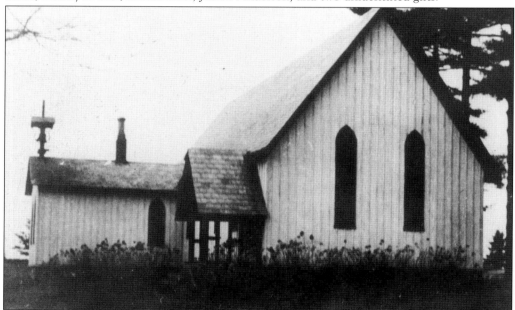

The Episcopal church in Allentown, believed to have been organized c. 1730, occupied various buildings prior to the 1869 construction of this board-and-batten edifice. The provenance of the image is obscure. The building may be the one sold to the Catholic church. The Episcopal church later occupied a North Main Street site on which a bank was built in the second half of the 20th century. (Collection of the Allentown-Upper Freehold Historical Society.)

Five

PEOPLE, PLACES, AND EVENTS

Earle W. Hendrickson, a 1929 graduate of Brown who obtained early stage experience there, founded the Allentown Dramatic Club that fall. Their premier presentation was *Deacon Dobbs*. The players are pictured in a 1931 production, *The Queen of Kingdom Corners*. The performers are, from left to right, Charles Cahill, Ben Yard, Zoltan Breta, Helen Burk, Julia Murphy, Horace Carl, Eliza Ford, Earle W. Hendrickson, and Etta Sprague. Judging from this picture, would you have attended? (Collection of the Allentown-Upper Freehold Historical Society.)

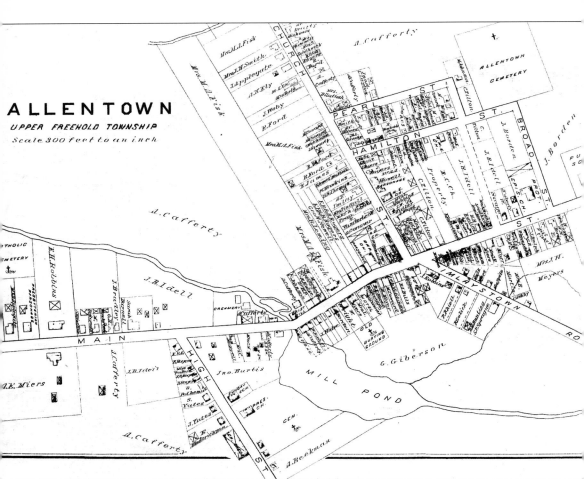

The extant street layout shown on the large-scale Allentown plan from the Wolverton 1889 *Atlas of Monmouth County* depicts both familiar and no-longer-standing properties. Church Street and Imlaystown Road (now Waker Avenue), which divide Main Street into its north and south sections, are part of County Route 526. The still-standing Methodist (nearer Main Street, page 23) and African Methodist Episcopal churches can be discerned there, as can the former location of St. John's Roman Catholic Church. The Baptist church (page 44 and in the Main Street scenes) is one of the larger properties on South Main Street. The Imlay House (pages 20–21), then owned by M.A. Fisk, had a large strip behind it, but one not really of sufficient length to accommodate the small airplanes that pilot Dr. Farmer (page 22) landed there. The gristmill (pages 26–29), the borough's most visible landmark, is at the bend of Main Street opposite the pond. To the left of the gristmill is the Mill House (page 32). The lots on Main Street south of the mill are more expansive than the tightly drawn business section. The extended course of High Street, part of County Route 539, can be traced on page 2. Depicted there is the Presbyterian church (page 42), which is the perspective point for the panoramic view on page 26. The former high school (page 47) was built on High Street around the lower margin of the map. The bank (page 15) had not yet been built on the triangle of land at the north side of Waker Avenue, but its original location a few doors to the north is discernible. The former Main Street locations of the Episcopal church (page 48) and the grammar school (page 46) are on the right. The Main Street designations may seem confusing when looking at the directional arrow. The street actually runs northeast to southwest.

50

"When you come to a fork in the road, take it," quips the contemporary whimsical adage. This c. 1910 image, on a Merriman photographic postcard, is a reminder that Allentown was at the nexus of major Colonial roads. On the right is the Allentown-Yardville Road, part of County Route 524, which extended beyond the latter town to Trenton. The original Old York Road on the left, part of County Route 28, led to Crosswicks and beyond to Burlington. In addition, a northerly route ran to Princeton, and a road to the northeast ran to Cranbury and more distant Middlesex County destinations. (Collection of Glenn Vogel.)

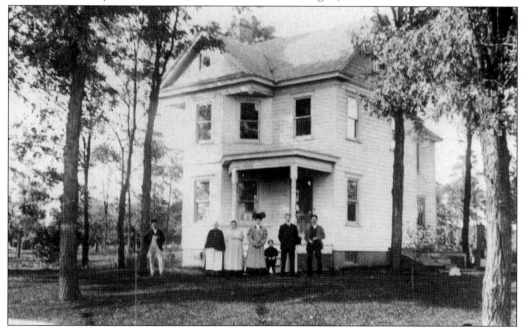

The Joseph Camp family is pictured in front of their Vernacular Victorian house, a pleasant structure with intersecting gables. Located on the Allentown-Yardville Road just west of the municipal border, the house (by then, much altered) was occupied as Drialo's Tavern when it was destroyed by fire c. 1980.

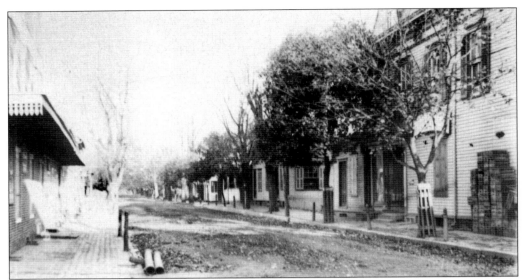

Church Street, pictured *c.* 1890s in a view looking west from Main Street, appears even narrower than it does in 2001, but it lacked motorized traffic then. The steeple of one of its churches, the Methodist, is faded from the center background. The Episcopal church (page 48) was founded here, and the African Methodist Episcopal church is still on the street at No. 72, beyond the view of this image.

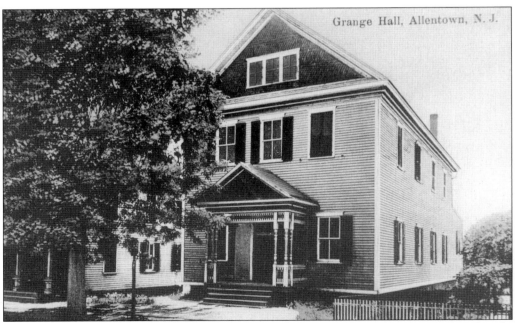

The Allentown Grange was organized *c.* 1870s; early records did not survive. Members bought a quarter-acre lot at 26 Church Street in 1905 and erected this hall, 34 by 90 feet at grade level, the men doing much of the preparation work. The hall, which had a stage in the rear of a large, high-ceilinged auditorium, opened in February 1906 and quickly became a focal point of Allentown social life. The hall was demolished in January 1969; a parking lot fills the site now.

Jacob Holmes Probasco, pictured on the right in 1919, secured a farm at 76 North Main Street in 1899. He is seen with sons Milton, center, and Alvah, seated around a potato grader, which sorted the spuds by size.

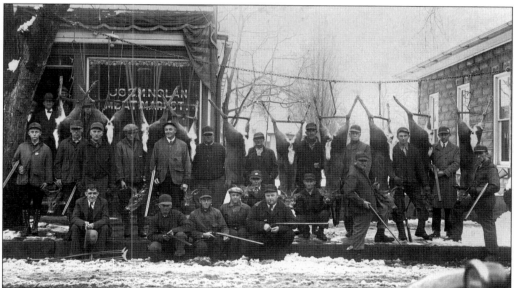

Members of the Ben Buckalew Club are pictured with their deed harvest on December 23, 1930, making one wonder if they ate venison that Christmas. They are, from left to right, as follows: (front row) Harrison Hutchinson, Harley Johnson, Gus Robbins, Edmund Tantum, Wilson Dey, Joseph Nolan, Charles Stanhope, and James Graham; (middle row) Clifford Tantum, Harry Dey, Albert Taylor, Gilbert Van Hise, Forman Hendrickson, Bucky Roe, Luther Pullen, William Taylor, Charles Spaulding, H. LeRoy Tindall, Joseph Schooley, and Warren Taylor; (back row, in doorway of Nolan's Meat Market) unidentified, Charles Tilton, Charles Haverstraw, and Donald Gordon. (Identifications courtesy of the *Allentown Messenger*.)

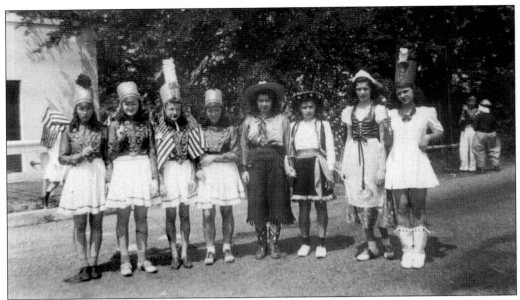

This octet of girls looked their patriotic best for the July 1940 parade. They are, from left to right, Madeline Merritt, Roberta Schooley, Mary Alice Probasco, Peggy Storms, Marion Conine, Camille Oswald, Gloria Saks, and Alice Ely. The boys in the background, who look out of it both figuratively and literally, are Joe Sadobi (left) and Wes Ayres.

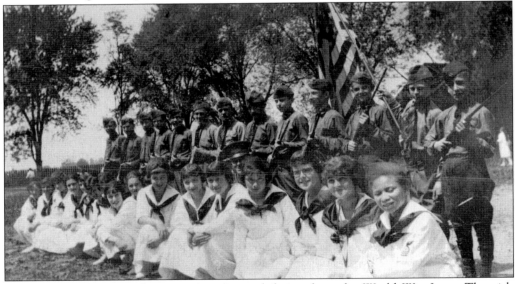

This larger group is another patriotic portrayal dating from the World War I era. The girls are, from left to right, a Hulse girl, Dorothy Fredericks, unidentified, Nellie Malvan, Dorothy Warren, unidentified, Margaret Graham, unidentified, Lois Gordon, Bessie Hallie, Ruth ?, Myrtle Dye, Lillian Conine, Florence Rogers, Carolyn Burk, and Blanche Johnson. The man in the middle is Capt. Warren Taylor. The boys are, from left to right, Ira Stout, Elwin Robbins, Norman Johnson, unidentified, Hilman Hendrickson, Charles Childs, Arthur Burtis, Burtis Hunsinger, a Wikoff boy, Albert Camp, Emlen Hutchinson, a Stout boy (capital S), and Frederick Anderson.

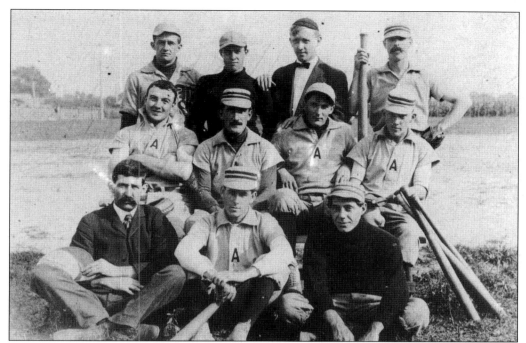

Look at the thick handles of their bats. And why, judging from the image's *c.* 1900 date, are not some of them crossed on the ground in the period's classic pose? This Allentown baseball team included, from left to right, the following: (front row) Clarence Bergen, Gus Robbins, and a Longstreet of Lambertville; (middle row) C. Forman Hendrickson, Dr. Harry Anderson, Albert Taylor, and Jewell Ford; (back row) Edward Frembles, Eddie Pumyea, Bergen Ford, and Hyatt Smith.

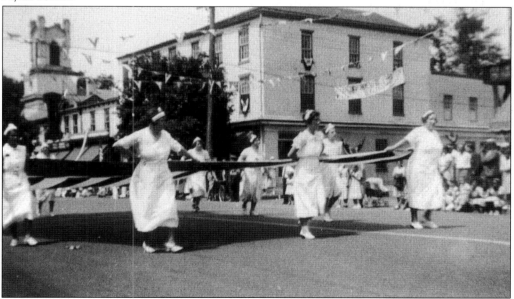

Unidentified women, apparently in nurse's uniforms, are pictured at a *c.* 1935 Memorial Day parade carrying a huge flag. The intersection is Main and Church.

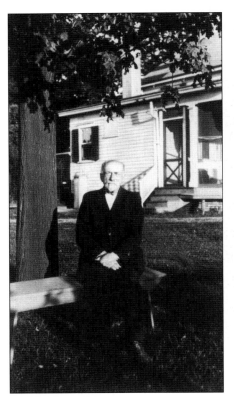

Josiah S. Robbins, born c. 1842, lived all his life in or around Allentown. He taught school at one time, but his mechanical abilities and agricultural interests brought him fame and wealth as inventor of the Robbins Potato Planter. Placing potato seeds in the ground had been an arduous manual process; early devices, such as the Aspinwall, were ineffective. The principle of Robbins's machine was the falling of seeds from a hopper onto a notched wheel, which dropped the seeds at a prescribed rate (for spacing) into a furrow. His major patents were in 1892 and 1895. Robbins retained a right for a $3 royalty for each sold by the manufacturer, initially the Bateman Manufacturing Company of Grenloch, New Jersey. His two-man planter was supplanted by single-operator machines by the 1920s, but the Robbins was a major advance in its day. Josiah, who is pictured in 1929 at his Allentown home (page 40), died in 1937. (Rutgers Special Collections and University Archives.)

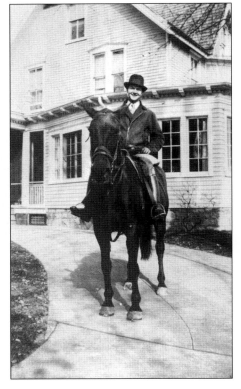

Earle W. Hendrickson, a 1929 graduate of Brown University, is mounted at his house at 62 North Main Street. He married Marjorie Naylor and was partner in the potato merchants Hendrickson and Delatush. Hendrickson served as mayor of Allentown for many years. (Collection of the Allentown-Upper Freehold Historical Society.)

Albert Robinson (born on April 13, 1843, in Salem County) began a 45-year education career after his studies at Union Teachers Seminary in Shiloh, New Jersey. He was a longtime principal of Allentown High School, retiring in 1915. He became mayor c. 1900 and served for so long that at his January 1, 1934 retirement, the observation was made that many residents were unaware of his earlier professional career. Robinson was a proponent of the public works that early made small Allentown a model among similar municipalities. He was a leading advocate of a borough water system. Robinson, an outdoor recreation enthusiast, Republican, and Presbyterian (not necessarily in that order), married Elizabeth Smick in 1872; the couple had four children. Robinson is pictured late in a lengthy life; he died on January 17, 1938, in Burlington County. (Collection of the Allentown-Upper Freehold Historical Society.)

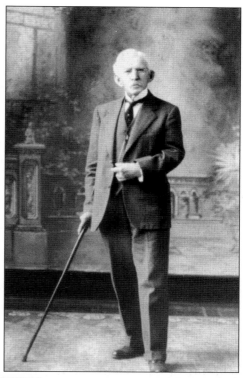

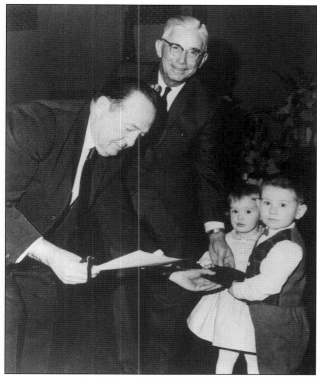

Charles I. Smith, a native of Freehold, moved to the Allentown area in 1912, living at Baker Hill Farm (page 120). He served various public bodies, was a member of the Upper Freehold Baptist Church, and was a director of the Farmers National Bank. Smith is pictured being sworn in for his second term as a member of the Monmouth County Board of Chosen Freeholders, the oath being administered by Russell Woolley. His grandchildren Terry and Stephen P. Dey III look on. Smith died on May 6, 1978.

De Forest and his wife, Lillian Ely (both born in 1905), are pictured in 1930. After becoming blind in a hunting accident in 1941, he demonstrated remarkable resourcefulness, notably in his ability to perform building work, which included the remodeling of 49 South Main Street. In addition, he developed tools for use by the sightless. Lillian, an artist and housewife, worked for the New Jersey Department of Transportation. They died in 1987 and 1994, respectively.

Ely built, substantially by his own hands, his family residence in 1934 at 10 Gordon Street, which was then at the rear of the mill property. He followed magazine-published plans, manually dug an extra-deep basement, the exertion of which caused him to reduce its width by two feet. Thus a planned center hall was omitted. Peter Wikoff is pictured in 1947 on the porch of a house that remains unchanged except for the removal of the front shrubs and the trellis.

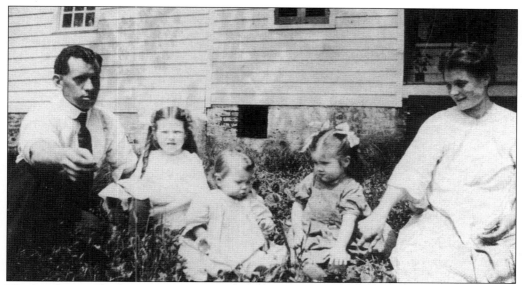

The handsome Charles Conine (left) family is pictured early in the 20th century; Eliza Ford is next to Conine. Alice B. Conine (namesake of the lender Alice Ely Wikoff) is on the right; daughters Lillian and May are next to her and in the center, respectively.

Beatrice L. Gordon, the daughter of Charles and Florence Gordon, was born in 1896 in New Sharon but lived in Allentown most of her life. She was a teacher and member of the Allentown Presbyterian Church. She died in 1980 while a resident of Hamilton Township. (Collection of the Allentown-Upper Freehold Historical Society.)

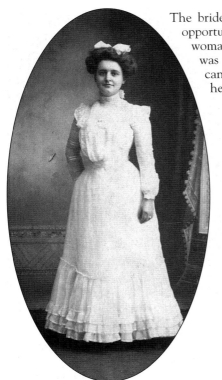

The bride from 1900 is unidentified but gives the reader the opportunity to imagine her state at the time. The young woman is attractive in a manner that all brides are. But was she confident, naïve, staring blankly, or frozen? We can only speculate, but her dress and expression justify her inclusion.

The rear of the Mill House (page 32) is the background for this *c.* 1906 portrait of Eliza Ann Cook Conine, born on September 15, 1854. She was wife of miller John R. Conine and great-grandmother of the lender, Alice Ely Wikoff. Eliza died on January 18, 1938.

Alvah Probasco is pictured *c.* 1904 in front of "Aunt" Alice Jones's candy store on Main Street, a place later known as the Allentown Candy Kitchen (page 18). Notice the former wood sidewalk and the brick street pavement. One hopes the bag of candy in hand did not cause him to forget his hat.

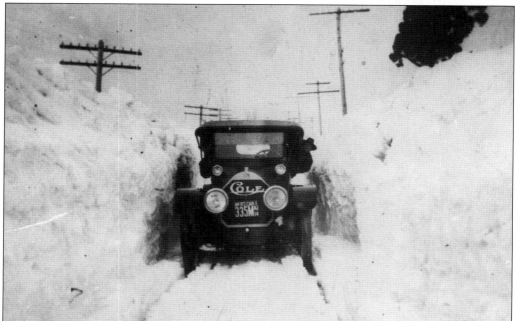

The first thought on seeing the narrow passage in this Allentown snowbank at an unidentified location was a hope that the car did not stall. However, the driver appears to have been able to fit through the window. License plates as a dating aid are better than automobiles, and few read as clearly as this 1914 example.

Identifying Gus Robbins's house, pictured on a stereograph card dated August 1868, has been elusive. However, its age and importance in the history of photography merit its inclusion. The caption, identifying the location as "East Church and County Road," is inconclusive. (Rutgers Special Collections and University Archives.)

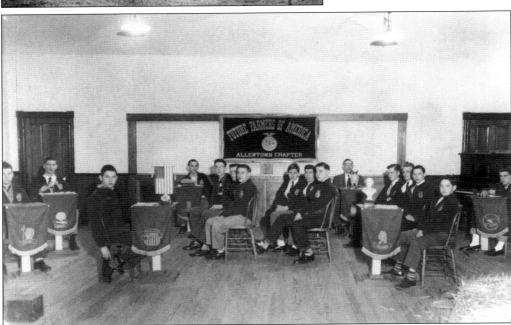

Members of the local Future Farmers of America are pictured in 1953 with banners and totems representing values. The man to the right of the banner with the owl is Mr. Peck, Allentown's vocational agriculture teacher. Why is the kid with the gavel off to the rear on the left? Perhaps the room was oriented in that direction, with the figures askew for the photographer. Stephen Perrine Dey is the middle of the three to Peck's right, and Charles I. Smith Jr. is second from the right.

Six

IMLAYSTOWN

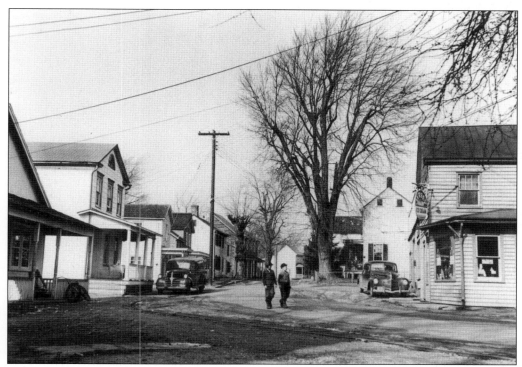

Imlaystown's popular lore boasts "the crookedest Main Street in America," one where nothing (well, hardly anything) changes. Occupancy of buildings and the peel of their paint change. This view looks north toward County Route 526 from the bend in Main Street. The post office is now housed in No. 41, the building partially seen on the left in this February 1949 photograph. The building on the right is vacant, retaining no hint of its former retail occupancy. (Rutgers Special Collections and University Archives.)

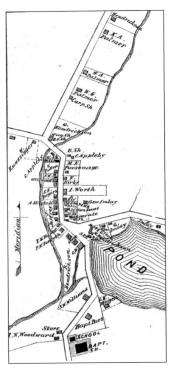

Imlaystown was part of a 2,100-acre tract patented in 1690 by John Baker, an East Jersey patentee who failed in an attempt to establish a settlement, which he called the Manor of Buckhole. The tract was acquired by Richard Saltar Sr., whose son Richard Saltar Jr. built a gristmill to the left of the letter P in pond on the map. Patrick Imlay acquired a 480-acre tract in 1710. The family stayed for generations, and the village is named for them. The major stream is Doctors Creek, seen at the lower left in this plan from the 1873 Beers Comstock and Cline *Atlas of Monmouth County*. Buckhole Creek is pictured running behind the Main Street properties. Main Street ends at an open plaza that could legitimately be called a square even in a larger town, especially in an era when cities hand out "plaza" addresses to buildings with no plazas. The square, also known as the triangle, is the white space in front of the pond in what the map designations depicts as a commercial area.

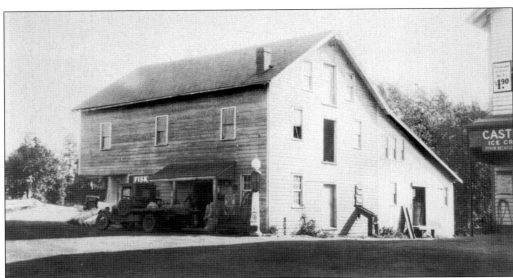

The original mill at Imlaystown was built before 1700 by Richard Saltar. The mill remains named for him, although it had a succession of owners. The structure standing in 1897, perhaps the original or a replacement, was destroyed in a conflagration. This mill, pictured in 1929, was built as a replacement. The building is instantly recognizable, although the gas pump and internal chimney are gone, and an external chimney was built at the juncture of the gable and lean-to section. Notice the flour sacks inside the rear door. (Rutgers Special Collections and University Archives.)

The mill at Imlaystown was owned by Ruben Hendrickson for the last third of the 19th century and his son-in-law Charles M. Rogers during the early 20th century. Rogers sold it to Walter E. Golden, who was, with his sons, the mill's last operator. Golden, pictured in 1958, was born in Princeton in 1889 and became a mill operator after high school. He married Laura Sexton in 1914. Golden bought this mill in 1920. The mill, which ceased operation in 1962, remained vacant for several years until purchased by Robert Zion in 1971 for remodeling as offices. Golden died in 1966 and is buried in the Old Yellow Meetinghouse Cemetery (page 104).

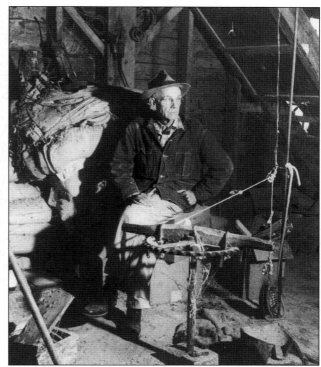

Robert Lewis Zion (born in 1921 in Lawrence, Long Island, New York) was educated at Harvard, where he earned a master of landscape architecture degree in 1951. He opened a New York City office in 1957 and worked with a number of the country's most distinguished architects. Zion, who sought to be closer to his Monmouth County home (having wearied of the long commute), converted the mill to offices in 1973. His firm Zion and Breen had commissions for major landscape projects at a variety of park, educational, office, institutional, and other commercial buildings. Their international fame was boosted by two 1967 New York City projects—the Ford Foundation Atrium, on 42nd Street, and the widely hailed but tiny (40 by 100 feet) Paley Park, on 53rd Street near Sixth Avenue. Zion wrote extensively and served on the facility of Pratt Institute. He had an active interest in historic preservation and took pride in his old farmhouse (page 115). Zion was killed in a traffic accident near his home in April 2000.

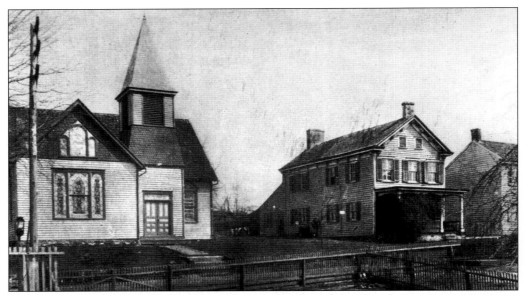

The Methodist church in Imlaystown is believed to have been founded in the third quarter of the 19th century, erecting this Vernacular Victorian edifice on the east side of Main Street near County Route 526. The church was enlarged in 1903, probably for the construction of the ell facing the street. The building is derelict now, and the adjacent parsonage went down at an unknown date. The house pictured in partial view on the right is No. 36. (Collection of Harold Solomon.)

A second Main Street scene, looking north, is pictured in 1958 closer to the curve in the road. The structures on the right, No. 28 with the gable on the end and No. 30 with a front gable, appear as one building, but they are two houses built close together. No. 47 is on the right. Main Street is as narrow as it is crooked. So, in this unchanging streetscape, vehicles pass uncomfortably close. (Rutgers Special Collections and University Archives.)

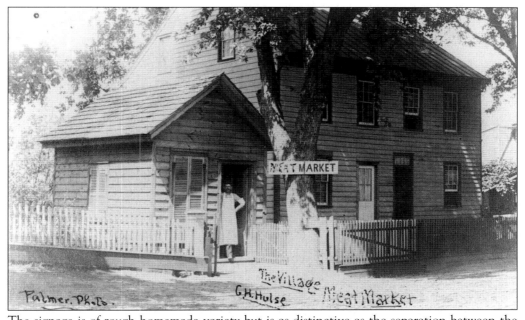

The signage is of rough homemade variety but is as distinctive as the separation between the residential and a former business building at 39 Main Street. The house is readily recognizable; the market gave way at an undetermined date to a parking area.

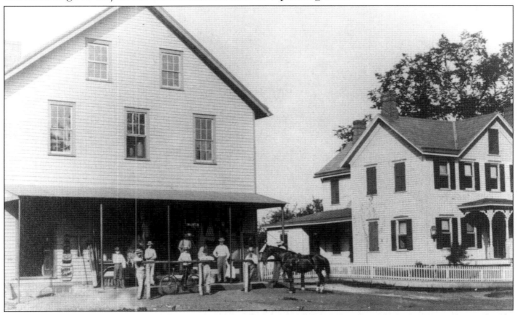

The crowd in front of B.P. Malsbury's general store reflects the establishment's informal role as a community center. Barclay Malsbury, who founded the business in 1890, took in his son in 1913, in time changing the store's name to Malsbury & Son. He was postmaster and maintained the post office in the store. Malsbury died in 1932. The building appears to be an 1897 replacement of one destroyed by fire. The house on the right, dating from the first half of the 19th century, is readily recognizable, although its side porch was later enclosed.

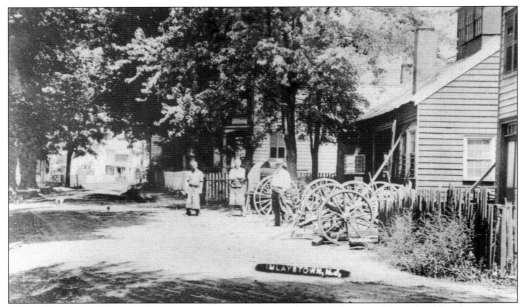

The exact spot of this Alick Merriman *c.* 1912 postcard is not identified, but the wheels suggest it is the wheelwright shop once on the north side of the "square." Merriman, of Howell Township, made small quantities of sharp photographic cards, typically of small villages overlooked by commercial publishers. His images are typically detailed scenes but are infrequently identified. The southern, or business, section of town was destroyed on September 19, 1897, by a fire that began with an explosion in D.G. Waldron's general store.

The "tavern and store" are not identified, but the 1891 date predates the 1897 conflagration. The fire leaped across the street and burned the stores next to the mill and the adjacent hotel, which was also owned by Ruben Hendrickson. It was probably the pictured building, which looks like a hotel. Although destruction was total, a news account reported that Imlaystown would not go dry, as six barrels of whiskey were rescued from the flames.

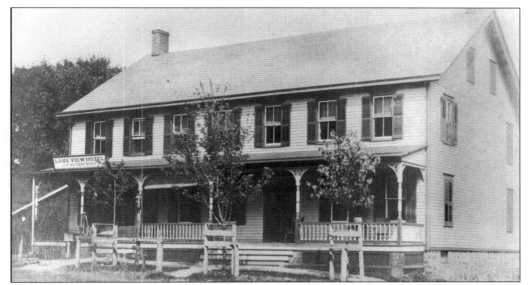

The Lakeview Hotel was built on the site of the destroyed one; its lot was on the square (technically a triangle) and overlooked the millpond. The last hotel usage is not known, but two-year owner Albert McNamee was reported in 1919 to have closed abruptly and left town. The building, once the Imlaystown Inn, is unchanged today and has been occupied for many years by the Happy Apple Inn.

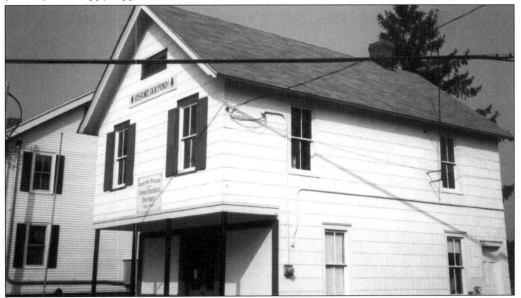

The lot opposite the mill had been occupied by a harness shop, store, and post office prior to the September 19, 1897 fire. An account published long after the fire indicated that Ruben Hendrickson had moved a former school from a location south of the pond to the lot opposite the mill. That building served as a hotel and tavern until the building shown above was erected. This building was later and for many years the Upper Freehold Township Hall, until replaced c. 1976 by the present hall on County Route 539. The building, pictured as refurbished in 1991, remains vacant today.

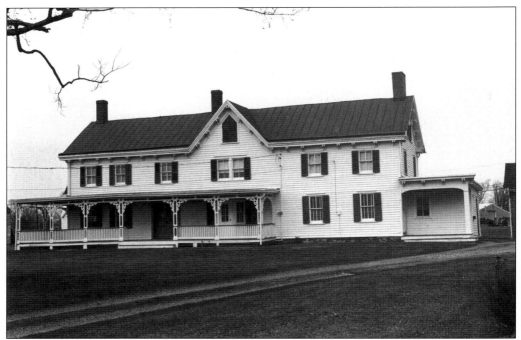

The Imlay house, located opposite the hotel on page 69, likely has early-19th-century origins (probably the section on the left) and was expanded with Italianate additions *c.* 1860–1870s. The property was acquired by Peter Imlay in 1727 and remained in the family until sold to Hendricksons *c.* 1915. The house, pictured in January 1982, differed little from its early-20th-century appearance and looks similar in 2001. (Monmouth County Historic Sites Inventory.)

This 1893 image of Gale (for Caleb) Appleby's shop survives with no historical background.

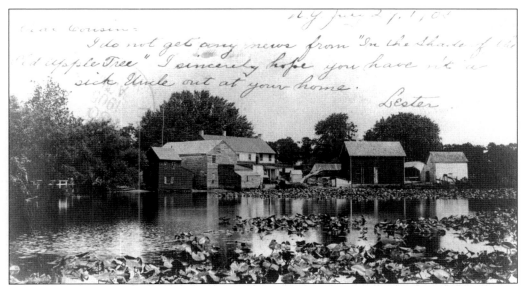

The 1905-dated message on what appears to be a photographic postcard and the handwritten notation at lower left that reads, "Before the Fire" suggest that this is a pre-September 1897 image that was printed several years later. One suspects the scene is the rear of the hotel that burned in 1897 (page 68) and the adjoining shops. If so, none of the structures stands.

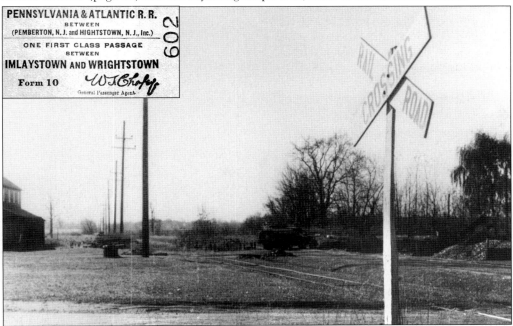

The Imlaystown railroad station was located on the south side of County Route 526, nearly a mile west of Main Street. In its early years, Imlaystown Station was a separate placename, but it was changed to Nelsonville by 1887 (page 107). The ticket shows one of the line's former names. An incorrect name appears on a major map, and in later years the Pemberton & Hightstown Railroad was the Union Transportation Company. (Rutgers Special Collections and University Archives. *Inset:* Collection of William Longo.)

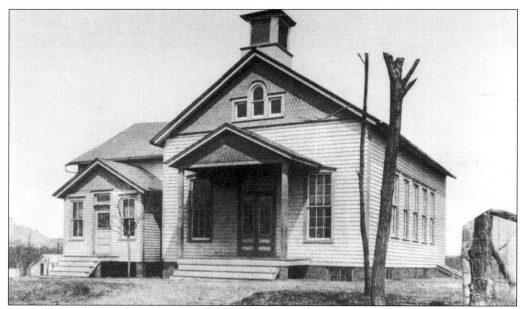

The earliest school in Imlaystown was a one-room structure reportedly built south of the village at the juncture of Davis Station and Emleys Hill Roads in the early 19th century and moved *c.* 1866 to a location on the premises of the Upper Freehold Baptist Church. The school was remodeled to a two-room facility in 1896 and replaced or remodeled in 1908, the year on this building's date stone. The building still stands, recognizable if one compares it with this image. It has been remodeled as apartments, one at grade level front, another upstairs, and a third in the rear. (Collection of Glenn Vogel.)

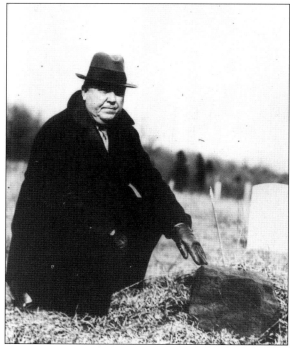

William R. Hendrickson, born *c.* 1866, began a long teaching career at age 18. He spent most of it at the Imlaystown School, including 35 years as principal, where he earned the reputation of "a gentle schoolmaster." Hendrickson worked hard for civic improvement, including for the construction of a new school. His other activities included service as an organist for the Imlaystown Methodist Church, a reporter of local events for two newspapers, a member of several fraternal organizations, and work as a local historian. Hendrickson, who had an interest in stories about Abraham Lincoln, is pictured *c.* 1930 at a memorial for Deborah Lincoln. He died in 1940, survived by wife Adelia, daughter S. Alva, and son H. Alvin. (Rutgers Special Collections and University Archives.)

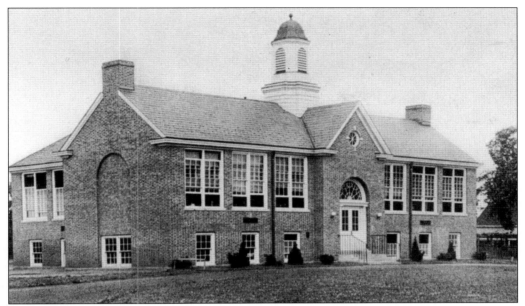

Instruction at the building opposite ended on December 24, 1930; the building was sold to supervising principal F.A. Ebert in March 1931. Classes reopened in January 1931 at this modern brick school at 202 Davis Station Road, directly opposite its predecessor. The building remains unchanged, although an electronic signal replaced the one formerly in the bell tower. The school now houses the Imlaystown campus of the Allentown High School.

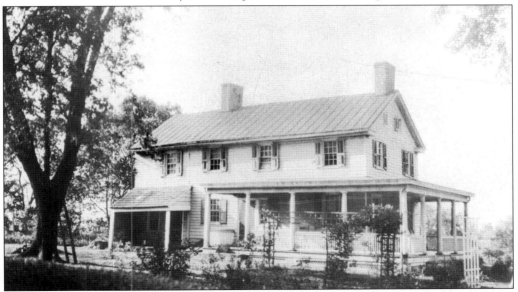

The c. 1930 original was labeled by photographer Carl Woodward, the noted agricultural educator and historian, as the former Baptist parsonage in Imlaystown, which contained Isaac N. Woodward's general store in the mid-19th century. The image remains ambiguous, not aided by 19th-century mapping. The 1860 Beers town plan has the words I.N. Woodward opposite the mill, and the 1873 map on page 64 shows the parsonage on the hill at the south side of the pond, near the church. (Rutgers Special Collections and University Archives.)

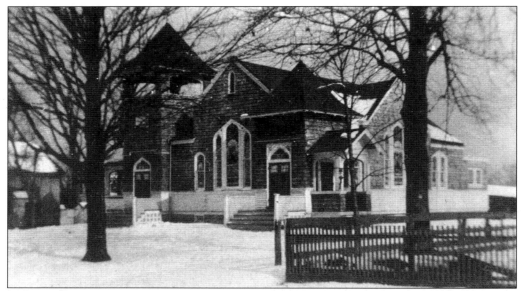

The Upper Freehold Baptist Church grew from an 18th-century gathering of Baptists who, under the leadership of James Ashton of Middletown, organized as the Crosswicks Baptist Church. They established a home at the Old Yellow Meetinghouse (page 104), later met at Cream Ridge, and moved their church from that village to Imlaystown in 1855. The church was enlarged in 1864, destroyed by fire in July 1903, and replaced by this one. The only visible change in 2001 is replacement wrought-iron rails.

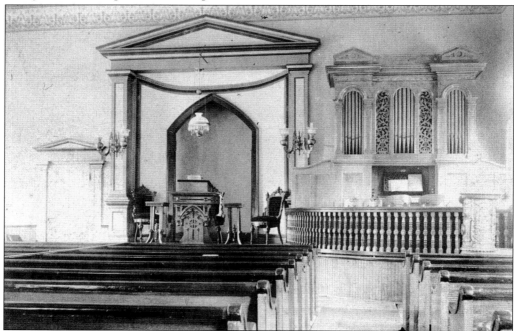

The church's interior is pictured perhaps a few years prior to its destruction. The blaze started in a chimney after a stove was fired to heat water for a baptism. Comparison with the new interior at the top of the next page indicates a simpler design for the replacement church.

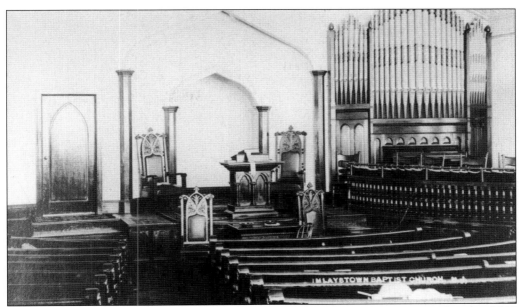

The most noticeable change is the new organ, which Andrew Carnegie supported with a $500 matching grant (before that term was common). It was built in Pomeroy, Ohio, and installed in early May 1904 prior to the July 25 dedication of the debt-free church. Also notice the curved pews and the Gothic design and furnishings elements. The image is a *c.* 1910 Merriman postcard. (Collection of Glenn Vogel.)

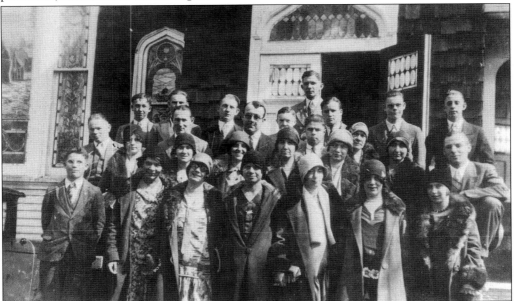

A photograph of an unidentified group on an early spring morning during the late 1920s—the men have shed their coats, the women merely opened theirs—provides an opportunity for a closer look at architectural detail. Notice the church's fine stained glass, including the Tudor-style transom and cladding on the front door, and the wood shingle throughout, except for clapboards under the windows.

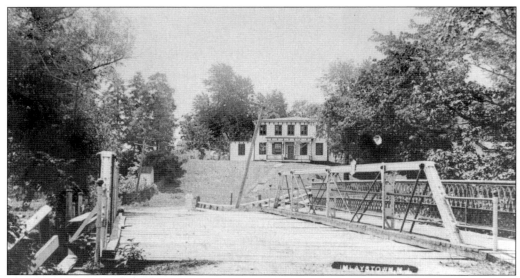

This *c.* 1910 Merriman postcard shows the former steel truss bridge that spanned the millpond, the view looking south toward the Italianate house at 211 Davis Station Road. The house remains little changed, although it is clad in vinyl and its brackets are gone. However, this bridge, U-11 on Monmouth County records, was replaced by a concrete span in the 1920s, which in turn was replaced by the present bridge in 1995. The new bridge was named by the Monmouth County Board of Chosen Freeholders in honor of Victor Booth, "an unwavering advocate for the restoration of Imlaystown Mill Pond." (Collection of Harold Solomon.)

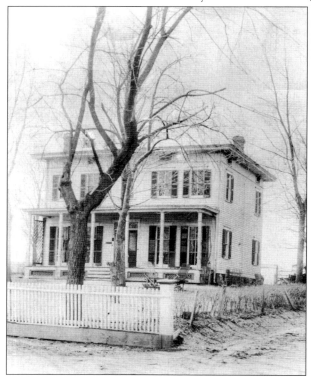

The Italianate house at 206 Davis Station Road was likely built in the 1850s by Isaac N. Woodward, the Imlaystown postmaster of the time. The house stands in fine condition, little changed, except a balustrade now surrounds the porch. Local lore calls this "the Doctor's House," for physicians Dr. Horace G. Norton, who owned it in the 1880s, and later owners Drs. Sinton and Aaron Heisen. It is now owned by Charles and Joyce Ottinger. Charlie, a man who can see the humor in most situations, maintains he continues the tradition, although his doctor of philosophy is in a different vein and he has no use for the X-ray room he found in the basement.

The Village Theater appears to reflect an active community and social life. Its location has not been identified, although a building opposite the Methodist church was once a hall, making it a possible location of the theater.

"The Strenuous City Cornetist on Visit to the Country" is pictured *c.* 1900 in anonymity. One wonders about his impromptu sign (or were the letters scratched in the negative?) and whether his city was strenuous or he was. Its age, size, and durability, especially with the strains of changing times, have instilled Imlaystown pride worthy of touting their own horn. In this instance, an eager outsider performs.

The 28-acre millpond, also known as Imlaystown Lake, was a longtime source of recreation. Residents esteemed it with pride, regarding the lake at the heart of the community. An unsafe dam caused the Army Corps of Engineers to drain the lake in 1981. Restoration of the lake was linked to the village's planned 1990 tercentennial celebration. After protracted disputes during which residents twice partially refilled the lake, the dam was rebuilt in 1995. The water flows, and the lake, pictured *c.* 1905, glistens again.

The September 3, 1990 tercentennial celebration aimed to promote Imlaystown community pride and historic stature. Events included a historical exhibit, a walking tour, crafts, music, food, and fun. Obviously, seeing this resident on the high two-wheeler would have made a more interesting picture, but the image from that day conveys the spirit of the festivities.

Seven

CREAM RIDGE

THE POST-OFFICE

The small village of Cream Ridge developed around the station of the Pemberton & Hightstown Railroad, which began operations in 1868. The post office opened in 1874 and operated out of the Edward W. Cross general store, which is pictured c. 1905. The Fillmore post office, which had been located a short distance to the east, closed at the same time. One can be confident of never being asked on a quiz show, "Where was the New Jersey post office named for the 13th president of the United States?" (Collection of Harold Solomon.)

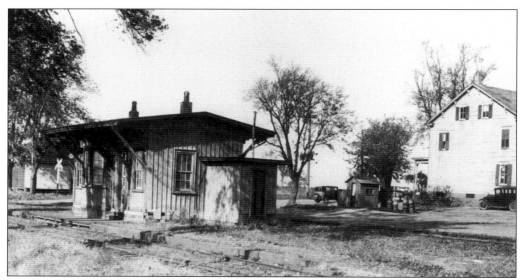

The Cream Ridge station, pictured c. 1930s, was located on the south side of Burlington Path Road, east of the tracks. The former right-of-way can be identified in 2001 by the presence of power lines and the location of the former store, which has changed little from this image or the one on the preceding page. (Rutgers Special Collections and University Archives.)

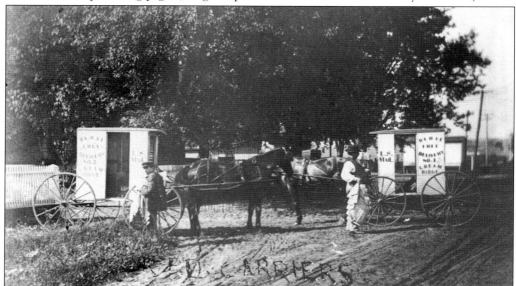

The *Allentown Messenger* reported that Rural Free Delivery Routes 1 and 2 were formed in 1905, the approximate date of this picture. The men were probably discussing potholes and dogs. The paper on July 27, 1905, described the routes. Route 1 was about 25 miles, serving 106 houses with a population of 425; Route 2 covered 24.5 miles with 450 people in 116 houses. Each was reportedly spread over 20 square miles, a seemingly great area in view of the size of the township and the presence of other offices. However, although Cream Ridge village is small, the Cream Ridge name in 2001 is spread over the wide area served by its post office. The paper also reported an increase in the number of named farms, perhaps done as a gesture to form an appealing address. (Collection of Harold Solomon.)

This unidentified street in Cream Ridge may be County Route 539. Cream Ridge village was named for the range of hills that runs along central Upper Freehold Township. The name's origin is often misattributed to the presence of the local creamery, clearly not the source, as the Cream Ridge name was used prior to the organization of the dairy industry. The first significant map reference to Cream Ridge is the 1851 Jesse Lightfoot large-scale sheet map of Monmouth County. (Collection of Harold Solomon.)

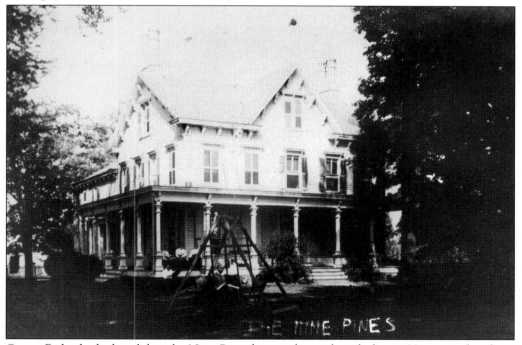

Cream Ridge had a hotel, but the Nine Pines has not been identified as it. However, the place, pictured c. 1930, has the character of an old rural hotel and possesses a pictorial appeal even in the absence of positive identification. (Collection of Harold Solomon.)

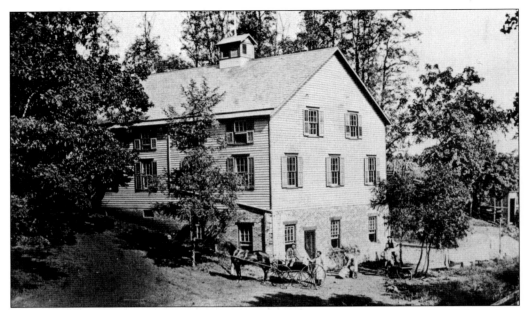

The Cream Ridge Dairy Association built this creamery over a stream on the Holmes farm on Holmes Mill Road in 1880. It was erected by Crosswicks contractor Thomas B. Anderson (within 33 days if he met his contractual terms) to a design by Ferdinand King. The business endured to c. 1902; the building, pictured in the 1890s, was expanded and remodeled to a residence, which it remains, bearing striking resemblance to its origins. The nearby Pemberton & Hightstown Railroad served the many dairy farmers for some years afterward.

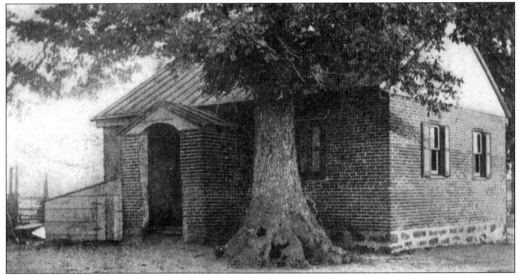

The small brick school that formerly stood on the west side of County Route 539 south of the village was an early replacement of a frame building erected c. 1820s. Instruction was probably consolidated elsewhere by the early years of the 20th century, and the building was "demolished by neglect" perhaps in the 1950s. The school was used for worship by local Mormons. An article on the Mormons was the occasion for the *Allentown Messenger* illustrating the school on August 24, 1905, a picture that was later No. 5 in their postcard series.

Cream Ridge Presbyterians built this church c. 1856 on a Burlington Path Road lot formerly occupied by the Baptist church (see page 74) while they were under the aegis of the Allentown church. In 1864, they received formal organization from the Presbytery of Burlington. This Gothic Revival edifice, pictured on a c. 1905 photographic postcard, was destroyed by fire in November 1908. It was replaced by the structure at 164 Burlington Path Road that was remodeled as a residence after abandonment for worship purposes. (Collection of John Rhody.)

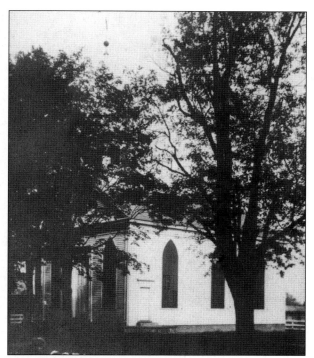

The William Jackson Blacksmith Ship stood (fragments still stand) at the northwest corner of Burlington Path and Harvey Roads. This was a community center and locale of the Fillmore post office, until the village moved a few hundred yards to the west after the Pemberton & Hightstown Railroad opened. The shop, built in the second quarter of the 19th century, is pictured in the 1930s. This was once thought to be the site of the Lincoln Forge (Upper Freehold Township's greatest historical error, a claim disproved in recent years).

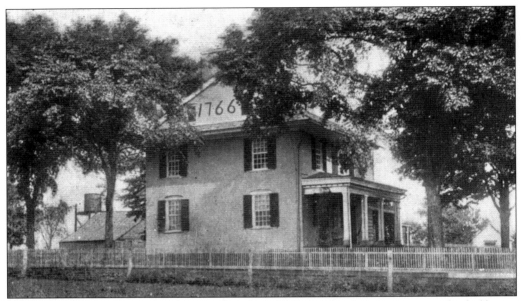

The patterned brick section showing the date 1766 is the three-bay, two-and-a-half-story original section of the Joseph Holmes Jr. house on the north side of Holmes Road, about 3/10 mile east of County Route 539. A two-and-a-half-story frame section and a two-story frame section, both set back from the main block, are attached on the east. The house was owned by generations of the Wikoff family for much of the 19th century into the 1970s. (Collection of Harold Solomon.)

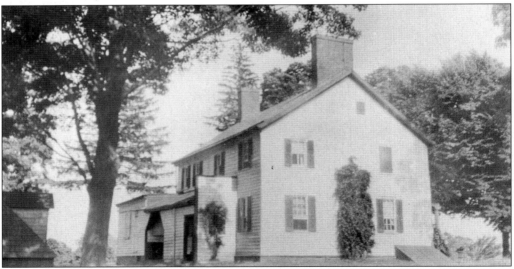

The Schanck farm, located on Holmes Mill Road near Cream Ridge, was once owned by Anthony Woodward III, grandfather of the reaper's inventor (see opposite). This 1931 picture of the house was previously published on the dust jacket of DeLafayette Schanck's 1940 book, more novel than the "memoir" he claimed, titled *The Road Upward Thru a Changing World— The Life Story of Emily Schanck Muller.* He claimed it was an account of crime and collusion, but public opinion regards it as shameless scandal mongering by an individual for whom "character" is a kindly epithet. (Rutgers Special Collections and University Archives.)

Schanck, who also wrote some local history, lived here with his sister Emily, who first married in her fifties. He went to Allentown after his brother-in-law moved in. The house was demolished c. 1990 for the construction of a much larger dwelling called Dreamland Farms. (Rutgers Special Collections and University Archives.)

The tongue of Ferdinand Woodward's early, unusual reaper is pictured in 1931, held by Carl Woodward Jr., the son of the photographer, in the field where the reaper was first used on the Schanck farm. Woodward's reaper was operated by being pushed ahead of the horses that "powered" it. The cut grain remained on the ground. The market was captured by harvesting machines that both cut grain and bound the sheaves mechanically. (Rutgers Special Collections and University Archives.)

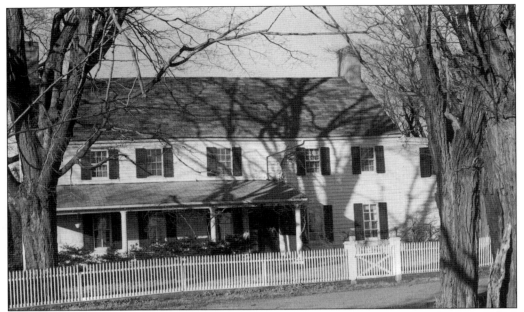

Part of the main block of the Joseph Holmes farmhouse at 31 Wygant Road originated in the 18th century, and an undetermined section, perhaps the two bays on the right, is a 19th-century addition. There is a one-bay service wing on the far right. (Monmouth County Historic Sites Inventory.)

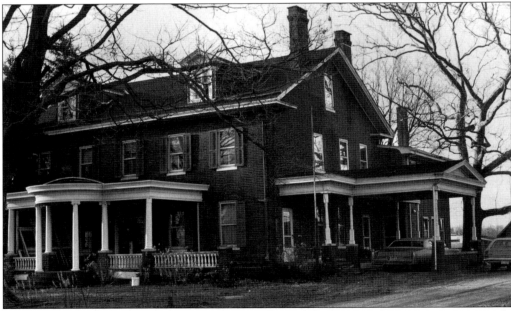

The John R. Lawrence House at 92 Holmes Mill Road, built *c*. 1790s, is an important early example of a Federal brick house in Monmouth County. The porch and porte cochere on the north side are 20th-century additions. After three generations of Lawrences owned it, the house passed to the Holmes family in the latter 19th century. The mill on page 121 was once attached to this property. (Monmouth County Historic Sites Inventory.)

Eight

HORNERSTOWN

Hornerstown is a small ancient village centered around the intersection of Main Street and Arneytown-Hornerstown Road, the suspected street of this unidentified *c*. 1910 photographic postcard. The place may have been named for Joshua Horner, who operated a gristmill and sawmill by the 18th century. The Horners, accused Loyalists, apparently lost their property in a Revolutionary War–era seizure sale. (Collection of Harold Solomon.)

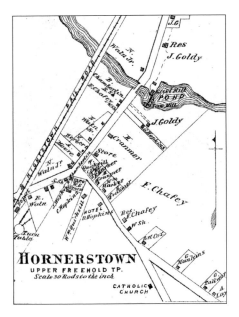

HORNERSTOWN
UPPER FREEHOLD TP.
Scale 30 Rods to the inch

Hornerstown was "Treat's" on the 1781 Hills Map of Monmouth County, perhaps for the depicted mill only. A 1789 reference to Hornerstown appears in the County's Road Returns, and the first major mapping with that name is the 1834 Finley. This large-scale plan is from the 1873 Beers Comstock and Cline *Atlas of Monmouth County*. Running from the left to the top is Arneytown-Hornerstown Road. Power lines in 2001 mark the path of the abandoned and largely torn-up railroad. Main Street runs to the bottom, leading to County Route 537. County Route 539 is located a short distance east of Lahaway Creek, just above the top of the map. Local obscurity notwithstanding, Hornerstown is famed among paleontologists for the discovery of "dinosaur" fossils (notably the mosasaurus) and geologists for its rich, thick, green marl deposits. Marl is decayed animal and vegetable matter that had wide application as fertilizer before chemicals seized the market.

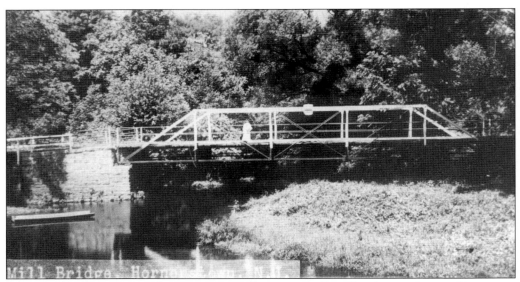

Lahaway Creek was spanned at Arneytown-Hornerstown Road by this single-span Pratt pony steel truss bridge, pictured on a *c.* 1910 photographic postcard. It was erected in 1893 by Dean & Westbrook, a New York bridge builder favored by Monmouth County in those times. Although support was reinforced over the years, this unique, historic bridge, identified as U-32 on Monmouth County Records, was replaced by a rather plain modern structure in 1990. (Collection of Harold Solomon.)

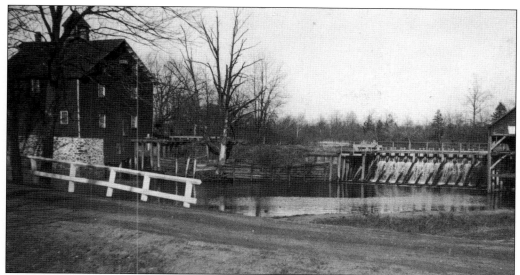

Although milling at Hornerstown began by the mid-18th century, it is difficult to identify the age of this mill structure pictured *c.* 1910, as many gristmills were lost to fire and rebuilt. Caleb Ivins owned the mill property by 1800 and may have erected new mills. John Goldy bought the property in 1862 and operated the mills for most of the rest of the 19th century. This building may date from sometime in the 19th century. It is believed to have been destroyed by fire *c.* 1940. (Courtesy of Gary Dubnik.)

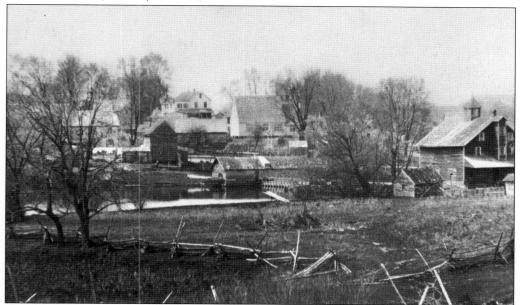

The buildings running diagonally in the middle of this *c.* 1910 photographic postcard are on the south side of Arneytown-Hornerstown Road. The mill pictured at top is on the right, and the Baptist church (page 90) is in the center. The gabled building to the right looks like the village's former school, but it is not positively identified. The shed in front of it came down *c.* 2001. The house behind the tree on the left is still standing in 2001. (Courtesy of Gary Dubnik.)

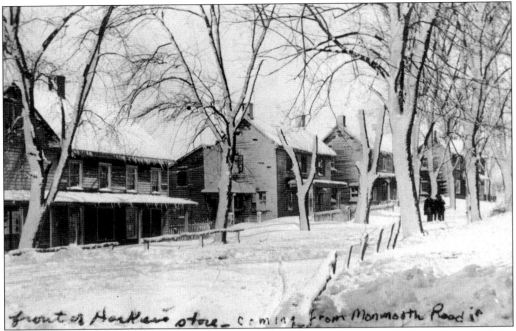

front of Harker's store — coming from Monmouth Road if

This *c.* 1910 image probably depicts the row of houses on the east side of Main Street where three end-gabled houses stand at Nos. 31, 29, and 27. (Collection of Harold Solomon.)

The Hornerstown Baptist Church, pictured *c.* 1910 and located on the south side of Arneytown-Hornerstown Road, was built *c.* 1890s. The view, looking east, shows the dwelling at No. 8 on the left. (Collection of Harold Solomon.)

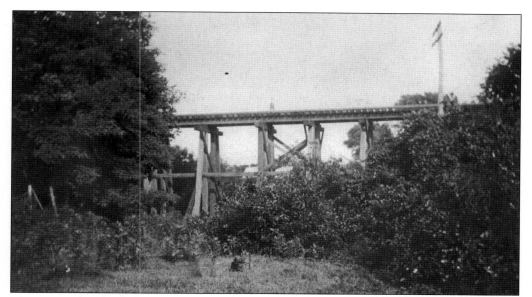

The Pemberton & Hightstown Railroad was begun at those Ocean and Mercer County terminuses respectively, meeting during construction at Hornerstown and opening in 1868. The railroad in Hornerstown included a freight yard with a turntable, a sidetrack at the marl pits, and this high bridge over the Lahaway Creek. The bridge still stands in 2001, is crossable, but beware of broken planks. It can be viewed from the bridge on Arneytown-Hornerstown Road. The image is a *c.* 1910 photographic postcard. (Collection of Harold Solomon.)

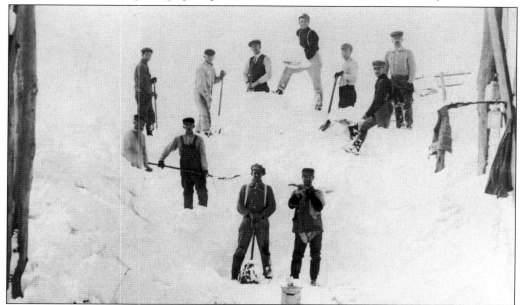

The blizzard of March 1, 1914, left massive snowbanks in western Monmouth County. These workers are pictured near the high bridge and include, clockwise from lower right, Jim Hopkins, Bert Baylies, Spath Hammel, unidentified, Charles Emley, Charles Higgins, "Boss" Cottrell, Raymond Johnson, Raymond Hopkins, Earl Norcross, and Dave Leming. (Collection of Harold Solomon.)

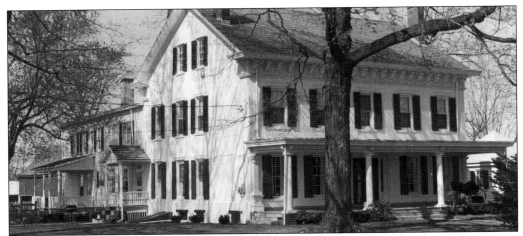

The Richard Waln house, now known as Walnridge Farm, on the north side of Arneytown-Hornerstown Road about one-half mile west of the village, is one of the township's most substantial five-bay farmhouses. Owned in the late 18th century by local miller Caleb Ivins, who may have built the one-story rear, the 248-acre farm was purchased for $11,000 in 1830 by Nicholas Waln, who left it to his son Richard, who likely built the two-and-a-half-story Italianate main block. The property's 19th-century structures include a rare icehouse and two wagon sheds. The place, which received the 1981 Century Farm Award, in 2001 is the veterinary headquarters of Dr. David A. Meirs's group and his standardbred stock farm.

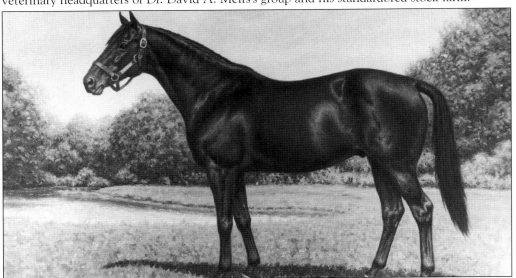

The standardbred industry developed in Upper Freehold Township during the past generation, spurred by the nearby presence of the nationally prominent Stanley Dancer, the 1972 establishment of the Sire Stakes, and the waning of the dairy industry, which provided a number of larger farms available for new use. Indeed, it is claimed that nowhere in America produces finer standardbred horses (trotters and pacers) than Upper Freehold Township. The finest may be pacer Direct Scooter, foaled in 1976 by sire Sampson and dam Noble Clare, who lives in retirement at Walnridge Farm, where he spent his entire stud career. The winnings of his offspring in 2001, the measure of a stud's success, is a huge $93 million (and growing). The image is from a painting by equestrian specialist Richard Stone Reeves.

Nine

WALNFORD

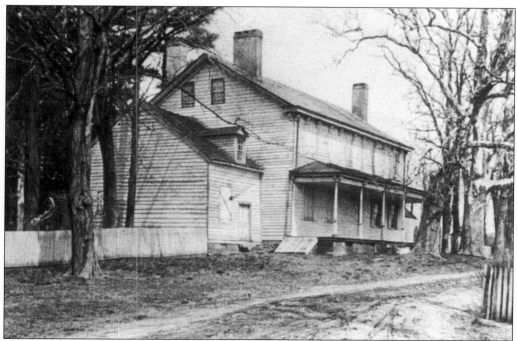

The village of Walnford developed around the gristmill established *c.* 1734 by Samuel Rogers at the ford at Crosswicks Creek. He added a fulling mill in 1744. This early-20th-century picture of the mansion completed in 1774 shows a wing on the left that was occupied as a store and post office. The office was known as Walns Mills when established on August 26, 1850, but was renamed Walnford a month later. It retained that name until it was closed in 1904; Ellisdale assumed Walnford's postal operation.

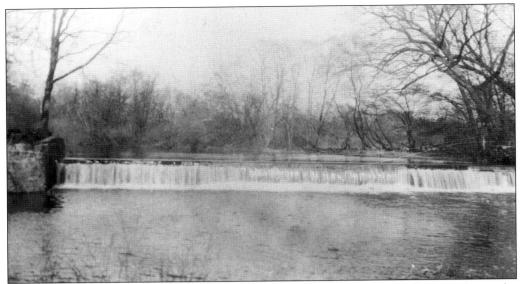

Crosswicks Creek was once an important commercial waterway, providing access to the Delaware River. Water powered the mill in its early years. However, the place is noteworthy for its installation of an advanced power mechanism, a T.H. Risdon turbine manufactured in Mount Holly. Archeological work uncovered parts of a former timber-framed dam, possibly dating from the 1770s, the timberhead race, and other ancient elements. (Rutgers Special Collections and University Archives.)

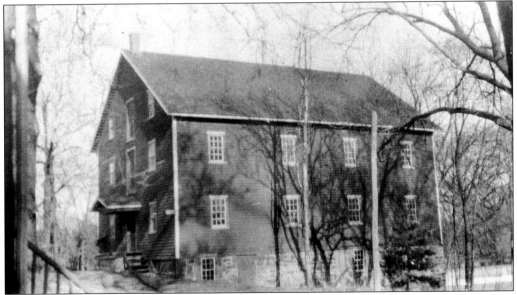

Richard Waln, a Philadelphia Quaker, purchased the property in 1772 and named it Walnford. Waln, who was engaged in international maritime trade, improved the property and gave it a substantial commercial footing. The gristmill was destroyed (probably by fire) in 1821 and was rebuilt the next year. An incendiary fire started by an employee burned that mill in 1872; it was replaced by this still-standing structure in 1873. Carl Woodward took the photograph in 1931. (Rutgers Special Collections and University Archives.)

The back of the mill is pictured in 1931 with an extant island and a no-longer-existing bridge. The economic viability of local milling of grain had been threatened since the late 19th century by gigantic Midwest milling operations that could undersell competition hundreds of miles away following the spread of fast and relatively inexpensive rail transport. Nicholas Waln, who had managed the property since 1790, married Sarah Ridgeway and inherited it following Richard's 1809 death in Philadelphia. Sarah R. Waln, their sixth child, was born in 1816; she married Jacob Hendrickson, who died in 1858 after being gored by a bull. The two Sarahs managed a 171-acre farm and improved the property, largely by selling land and mortgaging property. Unfortunately, the new commercial realities caused their fortune to wane. (See page 97.) (Rutgers Special Collections and University Archives.)

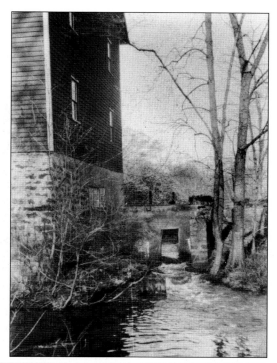

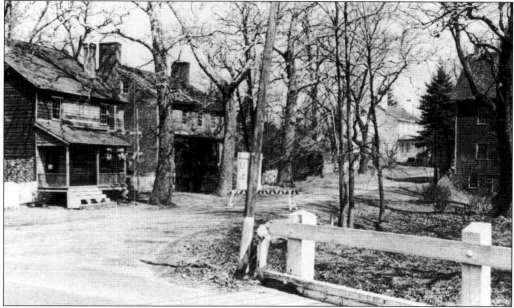

Walnford Road, looking east, suggests that the village developed around the mill (on the right). A 1772 newspaper advertisement for its sale described the 180-acre "plantation" as including a gristmill, a sawmill, a fulling mill, blacksmith and cooper shops, five tenant houses (including the one on the left), and a brick, two-family house (center and page 96). The latter two houses were destroyed in an incendiary fire set by local vandals on October 4, 1969. Their site is vacant in 2001.

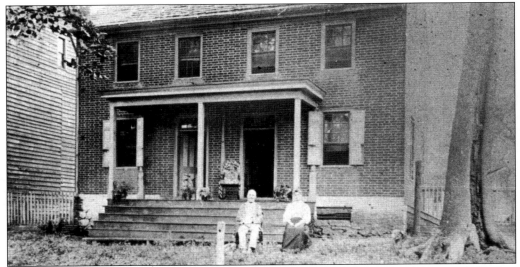

Samuel Rogers built this two-story, brick house presumably *c.* 1734 when he erected the first mill. Tradition states the bricks may have been fired locally, customary when there were nearby clay deposits. It was described in his 1744 newspaper advertisement to sell the property as "large . . . commodious for two families." The subjects in this *c.* early-20th-century photograph are unidentified. The house was workers' quarters when it burned in the October 4, 1969 fire.

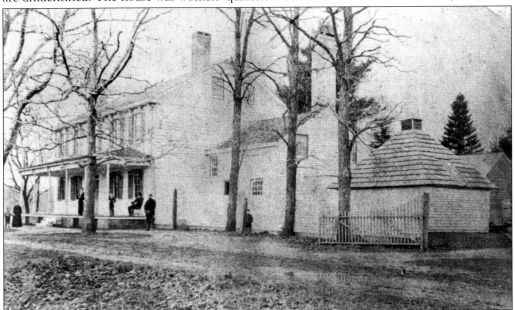

Richard Waln attained mercantile success at an early age and was only about 35 at the time of his 1772 purchase. In the next year, he completed the largest known pre-Revolutionary house built in Monmouth County. As a Quaker who favored the British during the war, he may have been motivated by safety concerns when relocating his family from cosmopolitan Philadelphia to this wilderness. British forces stopped here in June 1778 during their march from Philadelphia across New Jersey. The subjects in this early-20th-century photograph are unidentified; it shows an unchanged icehouse on the right.

The man is Richard's son Nicholas, who was born in Philadelphia on November 28, 1763, and helped manage the estate in the later years of his father's life. He married Sarah Ridgeway (right), who was born in 1779 at Salem, New Jersey, and inherited Walnford following Richard's death in 1809. Nicholas expanded the property greatly, rebuilding the mill destroyed in 1821 with a larger, improved one. After he died intestate in 1848, the family reached agreement whereby daughter Sarah would get the mill after her mother's death. The elder Sarah died in 1872. (Collection of the Monmouth County Park System.)

The portrait shows Sarah Waln Hendrickson, who died on March 15, 1907, at age 90. She was indebted to her African American servant of many years, John Wilson, and willed him her property, including the Walnford realty, to satisfy his claim for unpaid wages and other sums he had advanced her. Sarah's family contested the validity of the will, claiming she was impaired in her later years. The case was decided in favor of Wilson; her great-nephew Richard Waln Meirs and his wife, Ann, bought the property from him. (Collection of the Monmouth County Park System.)

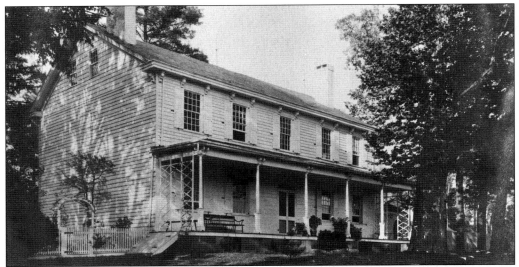

It is believed that the mansion's simple design and sturdy construction are reflective of Richard Waln's Quaker tastes. Richard Waln Meirs, who used Walnford as a summer home, began a remodeling program about two years after purchasing the property from Wilson; he incorporated Colonial Revival motifs and concepts popular at the time. The store/post office (page 93) was removed. This exterior, part of a photographic survey of the project made after its 1915 completion, reflects a house that is ultimately little changed in 2001 after an extensive Park System restoration. An exterior chimney is now on the west elevation pictured, on the left. (Collection of the Monmouth County Park System.)

The large hall is of room-sized proportions, typical of large, late-18th-century houses. This striped green hall carpet was copied at the Philadelphia School of Industrial Art's textile school, which performed every operation from raw fiber to weaving. The house now displays similar chairs, but they are faithful reproductions. (Collection of the Monmouth County Park System.)

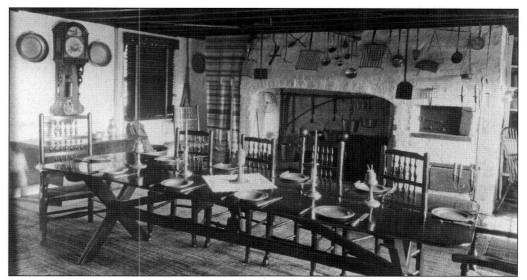

The kitchen is pictured in 1915 furnished with utensils typical of the late 18th century. Some of the smaller items remain; an exact reproduction of the table was installed by the Park System. After Richard Waln Meirs's death in 1917, milling stopped, but his widow, Anne, maintained a dairy farm. She married Benjamin Rush in 1947 and sold a major section of the property the next year, but retained 41 acres, including the mansion, mill, and other farm buildings. She left the property to her son William W. Meirs at her 1958 death. (Collection of the Monmouth County Park System.)

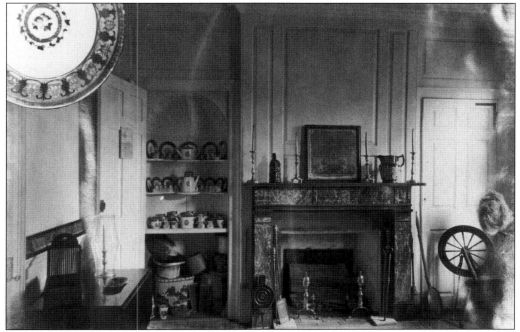

The inset Chinese export porcelain, which Waln records indicate was possessed by the family, is an example from the cupboard. A second cupboard was later installed on the right background. (Collection of the Monmouth County Park System.)

This bedroom, pictured in 1915, is behind the hall. Edward K. and Joanne H. Mullen purchased Walnford in 1973. Their stewardship embraced care and cultivation of the property's historic stature; they secured listing on the National Register of Historic Places and made the generous donation, which enabled the property to become part of the Monmouth County Park System. (Collection of the Monmouth County Park System.)

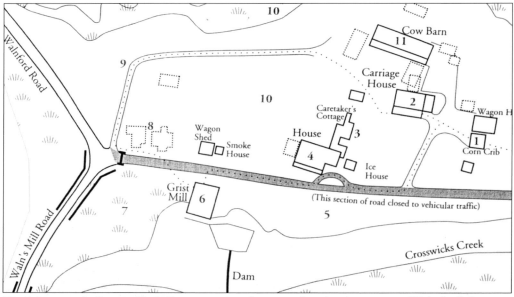

The Monmouth County Park System acquired surrounding land to protect Walnford's historic setting and undertook an extensive restoration of the mill, mansion, and farm properties. Walnford's interpretation embraces a number of periods of the past, reflecting its long history and evolution over time. The site, part of Crosswicks Creek Park, is open daily. The mill is operational and produces usable corn meal, although its souvenir packages are not distributed for human consumption. During its many quiet hours, the mill area retains an ambiance that permits visitors to step virtually into the past. The two focal points of this chapter, the mill and mansion, are indicated by numbers 6 and 4 on this contemporary diagram.

Ten

AROUND THE TOWNSHIP

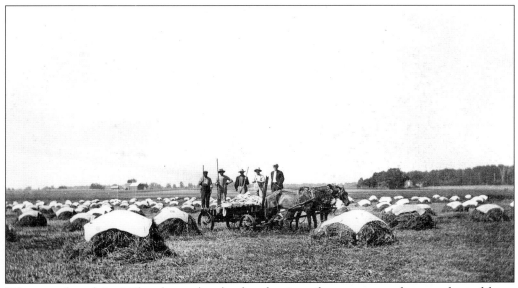

What are they doing? They have already placed quite a few covers on short stacks and have many more on the wagon. But hay is usually brought in the barn soon after cutting. And what are the covers? The picture is from *c.* 1920, so one wonders if the material is war surplus, such as tent canvas. Senior farmers in the township have looked at the picture without knowing "why," but publishing an image in ignorance often finds an answer.

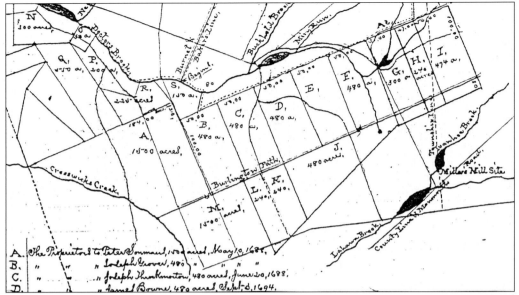

Between 1688 and 1695, several purchasers from Middletown acquired an extensive strip of land that spanned the township from the Walnford area to the future Millstone border. It ran along the Burlington Path and passed south of Imlaystown. That road, the major streams, and millponds may enable the reader to envision on a modern map this excerpt from Deed Book Volume 3, page 143. The buyers were (A) Peter Sonmans, (B) Joseph Grover, (C) Joseph Throckmorton, (D) James Bowne, (E) James Ashton, (F) Philip Smith, (G) John Stout, (H) Benjamin Borden, and (I) Job Throckmorton. The tract became known as the Middletown Men's Lots.

The octagonal school, in the East Branch School District, was built in 1819, perhaps a replacement for a 1739 school. Pictured in 1898, it was located at the juncture of East Branch and Eldridge Roads inside the present Assinpink Wildlife Management Area; it was later a public school. The eight-sided school in the region emerged in Bucks County (the first was in Oxford) apparently through the advocacy of father-son landscape gardeners named Moon. Some believe the shape enhanced acoustical qualities, an unfounded theory. Some octagons were nearly circular in shape. The East Branch school is part of a group of more than 100 similar buildings in the Delaware Valley and surrounding regions. Most date from the early 19th century. The pioneering work on the subject is *Temples of Learning: Octagon School Houses in the Delaware Valley* (the 1988 Columbia University master's thesis of Robert W. Craig, a historic preservation specialist with the New Jersey Historic Preservation Office). This structure is believed to have survived into the 1930s; the time and means of its disappearance are not known. (Collection of the Allentown-Upper Freehold Historical Society.)

County Route 524 is pictured in a *c.* 1930s view looking west at County Route 43. The tiny hamlet Coxs Corner surrounds the juncture. Although the Cox family had been in Upper Freehold since the 17th century, the author has not seen this placename on a map prior to 1917. The house on the left stands little changed on the southwest corner, although the barns were altered. The stone monument on the southeast corner was erected in October 1920 to honor five generations of the Cox family, noting that "Thomas and Elizabeth Blashford Cox were among the first settlers of the Province of East Jersey." It also states the Revolutionary War service of Gen. James Cox and other family members and indicates that . . .

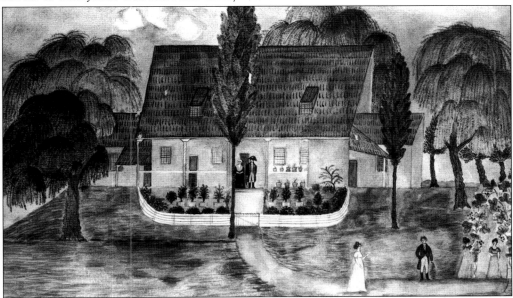

. . . the farm on which this memorial stands was known as Box Grove. The location of Coxs Corner (but not the name) can be found on the page 2 map. Box Grove is apparently an 18th-century house, but nothing has been revealed about its erection or existence. The name stems from the boxwood planted by General Cox's wife, the former Amy Potts. Its destruction by fire apparently predates 1920, judging by the past tense on the monument. The image is a watercolor by Amy Cox, their daughter.

103

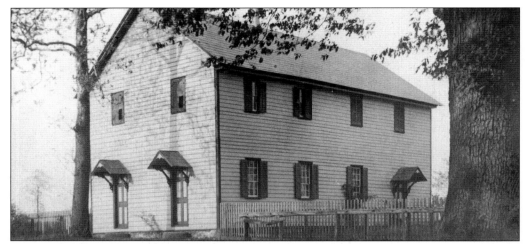

The original Upper Freehold Baptist Church, now better known as the Old Yellow Meetinghouse, was located on 25 acres (reduced to 18 in the 1970s) at the west side of Yellow Meetinghouse Road, about 6/10 mile north of County Route 526, just west of the township's border with Millstone. The church's organized history dates from 1766, but tradition dates local Baptist worship decades earlier. The first church on the site is believed to have been built c. 1720, when Thomas and Rachel Saltar deeded 25 acres. It was located a few feet from the present edifice, which was likely erected in the 1730s; the years 1731 and 1737 both have been attributed. The gabled ends face east and west, the latter the elevation pictured on this c. 1910 postcard. The southernmost bay, a later addition, includes a T-shaped center stairway to the 21-foot-deep balcony.

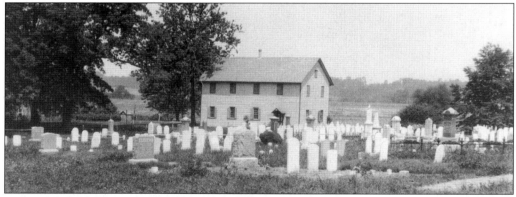

The cemetery's interments date from the church's earliest years to the recent past; the stones reflect a wide variety of material and funerary memorials. Baptist worship moved to the west by the middle of the 19th century. The congregation built a second church in Cream Ridge in 1846, which was moved to Imlaystown in 1855. The Old Yellow Meetinghouse fell into gradual disuse and was virtually abandoned by the end of the 19th century. The building was derelict at the 1975 founding of the Friends of the Old Yellow Meetinghouse, an organization that restored the church, obtained listing on the National Register of Historic Places, and continues caring for a building that has been used for many years only for a reunion service on the last Sunday in July, an event with an outdoor picnic luncheon. The historic stature of the place makes it as much a secular celebration of the township as a worship service. A Thanksgiving eve candlelight service was added in recent years. The events are open to the public. (Collection of Harold Solomon.)

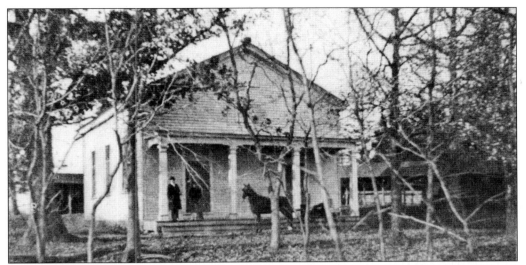

The Emleys Hill Methodist Episcopal Church stands at the northeast corner of Emleys Hill and Burlington Path Road. Their first edifice was erected in 1790, destroyed by fire in 1807, and rebuilt the same year, with the replacement church having fallen into disrepair by midcentury. The present church, pictured on this 1905 *Allentown Messenger* postcard, is a later (1855–1856) replacement. In 1913, the porch was enclosed and a square steeple was added as a memorial to Daniel Havens. The sheds, barely visible behind the church, were removed at an unknown date; in the recent past, a hall and education building were added there (the north elevation). (Collection of John Rhody.)

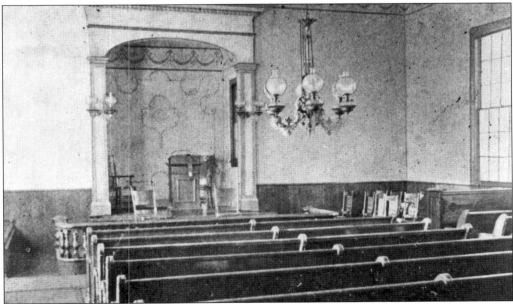

The church was moved 30 feet from the corner in 1969 and placed over a new basement. It stands close to the street and can be accessed via a staircase cut in the hill. This old chandelier is believed to have been purchased in the early 1880s. Stained-glass windows were installed in the late 1920s, and doorways were cut on both sides of the north end. The congregation is growing and is considering in 2001 the planning of a new church.

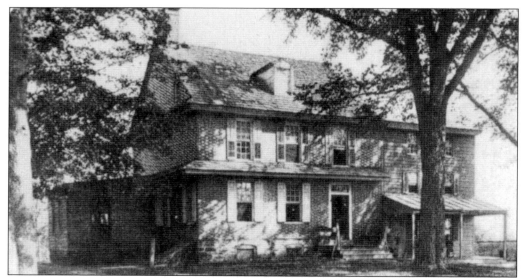

In 1706, Robert Burnett sold his son-in-law William Montgomery 500 acres, the origins of the Eglinton estate. The house, which predated the Revolutionary War, was described by a British officer in 1778 as "the most elegant mansion we have seen until reaching Monmouth Court House [Freehold]." The house, located on the north of County Route 524 about one-half mile east of the Old York Road, remained in the family for several generations. Pictured on *Allentown Messenger* postcard No. 9, the place was destroyed. (Collection of John Rhody.)

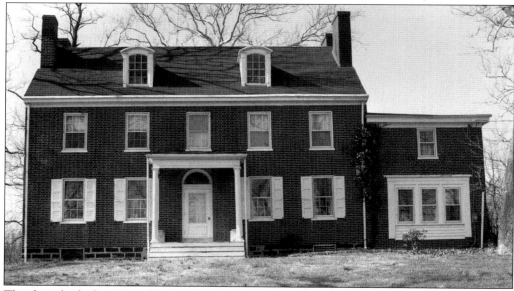

The fine, high-design, Federal-style Robert Woodward house dates from *c.* 1815–1830 and stands on the north side of Hutchinson Road, about a quarter mile east of the township's border at Province Line Road. Once part of a 2,500-acre tract patented to Anthony Woodward, its builder was his great-great grandson. The Flemish bond brick house on a coursed-stone foundation was constructed with the classic five-bay Georgian form. Its exterior Federal features included the bridged twin end wall chimneys and semicircular fanlight. (Monmouth County Historic Sites Inventory.)

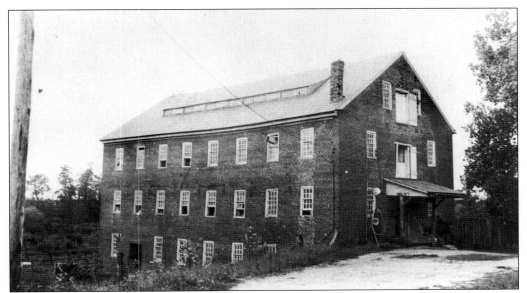

Kirbys Mill was located on the old Allentown-Yardville Road just east of the Mercer County line. It was powered by Doctors Creek, which once ran underneath the building (as seen on *Allentown Messenger* postcard No. 28). The building, dating from the first half of the 19th century and once a fulling mill, was converted to steam power in 1905. By then, it was grinding grain. The mill, pictured in 1931, was destroyed by fire at an unknown date, perhaps *c.* 1950s. (Rutgers Special Collections and University Archives.)

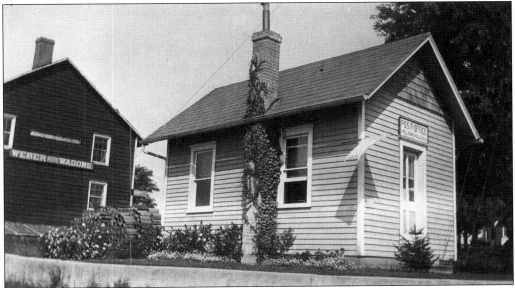

A post office was established at Imlaystown Station (page 71) in 1883 named Newell. Charles Nelson was the first postmaster and remained in that capacity after its name was changed to Nelsonville in 1887. In addition to the wagon shop pictured with the post office *c.* 1920, local industry included the I.S. Dawes & Son cider mill. After the Nelsonville post office closed in 1923, its region was served by Imlaystown. The building was moved to Allentown and in time "disappeared," recalled Fred Kneisler, lender of the picture.

Wilbur Fowler Rue, born in 1898, was a 1920 graduate of Rutgers and taught two years at Purdue. He farmed for a while, without any real inclination, and was likely relieved when the Rue farm, near Coxs Corner, was sold in 1935. Wilbur was a rural mail carrier for many years and later postmaster of Allentown, preferring the former position. He had built a house on the farm, where he is pictured in October 1933 with turkey Bill, and had the house moved to Allentown. There was his real love, as poultry was his passion. He raised a variety of birds, but Bill was a pet and is believed not to have met the foul end customary to his breed. Rue died in 1990.

George Probasco is pictured in 1934 with an early gas-powered mower. It appears simple, and he recalls it as reliable. This may be a good reminder for contemporary consumers faced with delicate, complicated equipment, including self-propelled mowers.

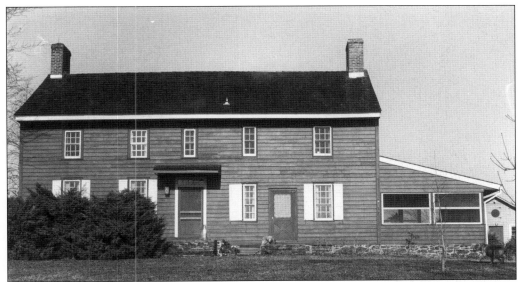

The origins of the Peter Gordon house on the north side of County Route 526 are obscured by later expansion. The earliest part was likely a three-bay, one-and-a-half-story structure on the east, or right. The western section was built as a two-story, mid-18th-century extension, and the eastern end is believed to have been raised to two stories later in that century. Peter and Elizabeth Gordon were Scotch Presbyterians, the background of many later owners of the house. (Monmouth County Historic Sites Inventory.)

This grain elevator, four stories tall at its highest point, is the area's last sizable structure of its type. Pictured in 1981, it is located on Imlaystown-Davis Station Road on the right-of-way of the former Pemberton & Hightstown Railroad and stands as a reminder of the township's major agricultural history. (Monmouth County Historic Sites Inventory.)

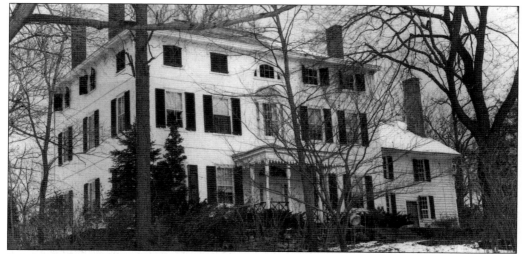

Samuel Gardiner Wright's 1810 Federal-style house at Merino Hill Farm on the north side of County Route 526, about 4/10 mile east of the Coxs Corner juncture, is one of Monmouth County's most important houses. It is affixed to a c. 1735 house (now a wing), which is one of the oldest structures in western Monmouth County. The property was recorded by the Historic American Buildings Survey and is listed on the National Register of Historic Places. Wright, a prominent Philadelphia merchant, used his farm as a country estate, naming it for his flock of Merino sheep, which were rare outside of Spain, a country that barred their export to protect a monopoly. (Monmouth County Historic Sites Inventory.)

Merino Hill remains part of a 280-acre tract, which was entered in the farmland preservation program by its fifth generation of Wright owners. Its 19th-century farm buildings include a horse barn, tenant house, wagon shed, and this 1832 storehouse/office (in addition to an early-20th-century cow barn). A hoist formerly carried material to the loft for storage; the ground floor functioned as a combined business office and store. Notice the decorative lyre over the door and an enframement that is more elaborate than a farm structure's; it was once part of a Philadelphia house. Both pictures date from 1981. The storehouse has been restored since. (Monmouth County Historic Sites Inventory.)

The Anthony Woodward House combines its ancient stone origins, the one-story wing on the right built *c.* 1700, with a fine Federal, five-bay, main block dating from *c.* 1800. Alternately known as Ashford, the house is located on the east side of Province Line Road, 9/10 mile south of Ellisdale-Walnford Road. Woodward, an English Quaker, purchased 2,500 acres in 1698; the family long owned extensive properties in western Monmouth County. The house faces south and includes farm buildings arranged in an open courtyard plan. (Monmouth County Historic Sites Inventory.)

The John Horsfull House on the west side of County Route 539 opposite Hill Road consists of a two-and-a-half-story, mid-18th-century Georgian five-bay main block on the left and a two-story wing. The two sections are believed to be contemporary, an unusual instance as time and different techniques or styles usually separate expanded early farmhouses. The Horsfulls were important early in the 18th century. Richard, a constable in 1720, owned 250 acres, leaving them to son John at this death *c.* 1752. John owned 680 acres by 1758, but much of the Horsfull property's 19th-century history is obscure. (Monmouth County Historic Sites Inventory.)

The *c.* late-1820s Abraham Tilton House on the south side of Ellisdale-Walnford Road, a half mile west of Hill Road, is a late but important example of high-style Federal architecture in Monmouth County. Abraham Tilton (1790–1860), who was from Burlington County and married Martha Meirs (1794–1878), bought 192 acres from the estate of John Ellis in 1826. The house, on a hill set back about 1,000 feet from the road, was recorded by the Historic American Buildings Survey. (Monmouth County Historic Sites Inventory.)

Members of the 4H Upper Monmouth Baby Beef Club are pictured in the early 1950s with their numbered specimens. Why do we see that end? The photographer would observe that it is what you see while photographing handlers leading their animals. The butcher might respond, "That's where the best meat is." Phyllis Potts is the girl with the glasses left of the banner; Stephen Dey II is the boy with the light hat to the banner's right. Wilson Dey is next to him, and Grace Potts is leading No. 12. Richard Potts is at the far right.

The origin of the Woodward-Ridgeway House, also known today as Heritage Hill Farm, located on the south side of Ellisdale-Walnford Road 3/10 mile west of Hill Road, is the 18th-century frame section right of the c. 1815, two-and-a-half-story Georgian main block. The house is located on a 173-acre farm (with a series of farm structures behind it) that was once part of the 2,500-acre Anthony Woodward tract (page 111). The builder of the house may have been one of Woodward's sons. A later Woodward generation lost the place for debts, it having been deeded to John Ridgeway in 1814. A pitched roof has been built on the frame section since the house was photographed in 1982; a well house is in the front. (Monmouth County Historic Sites Inventory.)

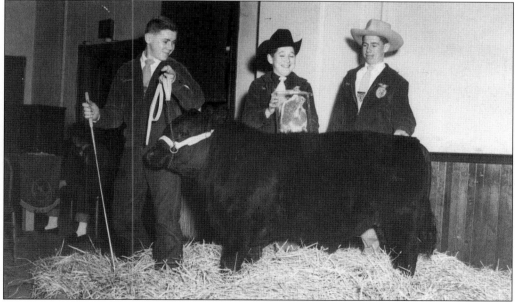

Holding the packaged steak over the baby steer suggests these boys obtained their market acumen in their younger years. The early-1950s picture reflects that the steer was raised for consumption. Leading "Beefy" is Woodrow Wilson Dey II, known as "Bud." Charles I. Smith Jr., who answered to "Smitty," holds the meat, and Stephen Dey II looks on approvingly.

Stephen Dey II is pictured at a tractor-driving contest at the 1953 County Fair at the old Freehold Raceway with an unidentified judge. His tractor has a great identification aid for the farm-deficient author: large letters, with even the model clearly visible. Stephen remains a tractor enthusiast, a helpful interest even for a veterinarian, as Peggy Dey remarked, "We bale 500 acres."

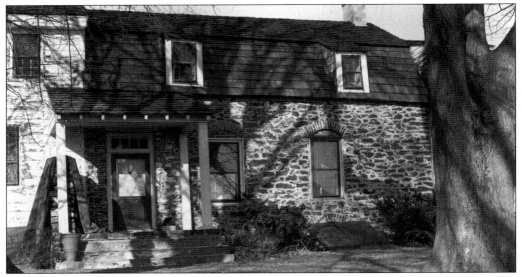

The one-and-a-half-story middle stone section (from around the second quarter of the 18th century) is the oldest of the much-expanded Coward-Hendrickson House on the south side of County Route 27, three fifths of a mile west of Imlaystown-Prospertown Road. The house is named for builder John Coward, who died in 1760, and Tobias Hendrickson, who married Rebeckah, a Coward daughter. Hendrickson's lengthy ownership lasted until his death in 1811. The house was recorded by the Historic American Buildings Survey and is listed on the National Register of Historic Places. (Monmouth County Historic Sites Inventory.)

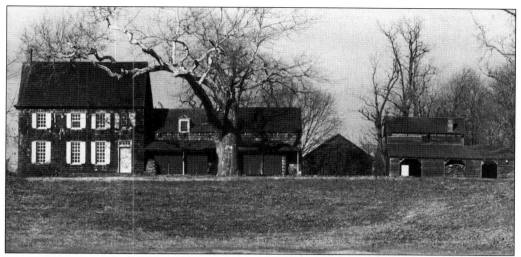

The John/Thomas Coward House (the joint name reflecting ambiguity surrounding its origin) was begun around the second quarter of the 18th century with the four-bay Georgian main block on the left. The ell to its right includes the original kitchen, which has a large cooking hearth in the south room and a dining room in the north end. The end-gabled building is a wagon house north of the dwelling; the ell is separated from the summer kitchen on the right by an open patio, the space obscured by the building behind. Thomas is son of John, who built the house on the bottom of page 114. Either may have built this one.

The property is located on the south side of County Route 27, a half mile east of Imlaystown-Prospertown Road. The rare surviving 19th-century icehouse is located behind the summer kitchen. The property was known in the late 20th century as Black Pine Nursery for owner Robert Zion (page 65), an ardent preservationist who restored this place and was an active spokesperson for maintaining the pastoral character of Upper Freehold Township. (Monmouth County Historic Sites Inventory.)

New Sharon is a village north of Allentown that spans Mercer and Monmouth Counties, the sections separated by Old York Road. The area was earlier called Cat-tail and Sharon, the New Sharon designation probably dating from the 1850 opening of a post office. The sender of this c. 1915 postcard provided a description, "New Sharon-near our home," that may have been understood by the receiver, but identification of the pastoral locale was elusive 85 years later. (Collection of Glenn Vogel.)

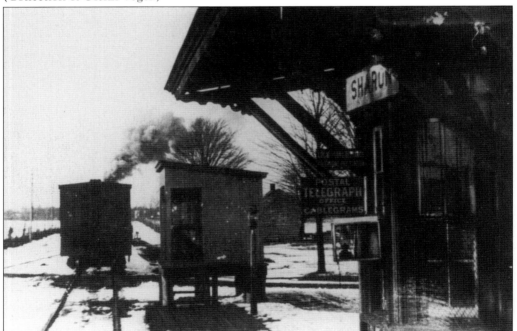

Sharon Station on the Pemberton & Hightstown Railroad, located on the southeast corner of Sharon Station and Herbert Roads, consisted of a 16-by-32-foot passenger station, pictured c. 1915, and a 16-by-30-foot freight house, along with a milk platform and cattle pen. The lamp in the box under the signs lit the call letter S. A hay press used to be located near the station, but the site is vacant in 2001, the station having been taken down at an undetermined time.

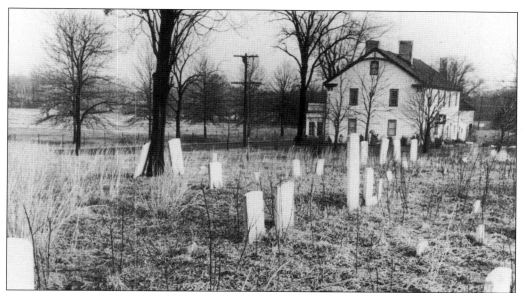

The New Sharon Methodist Episcopal Church was founded in 1812, located on the west side of Old York Road, north of Walters Road, or in front of the extant cemetery, which is close to, but barely visible from the road. The church was moved in 1949 to 1249 Extonville Road, outside of western Allentown, and remodeled as a residence. It remains there, resembling a 1950s ranch, as the upper story was removed. The gravestones seem sparser now, as some graves were believed to have been relocated. (Rutgers Special Collections and University Archives.)

The c. mid-19th-century farmhouse of the Probasco family is the background for the truck in the mud and its rescuer, pictured c. 1930. The house is on the Mercer County side of Old York Road (County Route 539); the family's farm is on the Monmouth County side. Upper Freehold Township has county highways as borders with three counties. Maintenance is usually by agreement with one county to attend to both sides of the road. The farm (page 118), once a large producer of potatoes, is now enrolled in the farmland preservation program and grows sod.

This *c.* 1935 picture is the older of two potato digger images on the Probasco farm. George Probasco is driving a *c.* 1930 International Farmall with the characteristic metal wheels of the time. The digger dug two rows, raising the spuds from underground and shaking off the dirt, leaving them on the surface for the pickers.

This digger from around 10 years later shows the potatoes being dropped while packed sacks from other rows are visible on the left. George is again driving, this time an Oliver, while hired hand Stanley Roe is gazing downward to ascertain a smooth operation.

The federal government encouraged heavy planting of potatoes during World War II by agreeing to buy the surplus at 90 percent of parity. Central New Jersey responded with a 25 percent increase in planted acreage. This wall of surplus potatoes from around 1945 resulted from a late local crop in a market that had been supplied from out of state. The government-purchased potatoes were gathered to be chopped for dairy cattle feed, to be offered farmers for free. The 1945 yield was 800,000 bags.

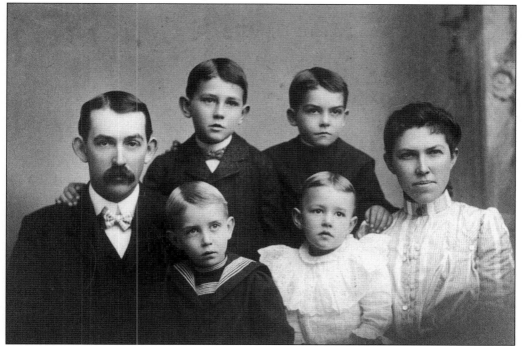

Jacob Holmes Probasco is pictured c. 1905 with his wife, Belle Dey Probasco. In front are their son Milton to his left and daughter Jean to her right. Sons Russell, left, and Alvah are in the rear. Alvah is father to George, whose farming pictures are on the preceding pages.

Baker Hill Farm on County Route 526 near Nelsonville was once part of the five farm holdings of Albert Nelson. Pictured *c.* 1930, the *c.* 1880 house left of the road still stands, and a new house is on the right, or north, side of the road. The substantial 25-by-82-foot barn at the far left contained basement stables that were described by Nelson as warm and comfortable, making one wonder how often he had to sleep there; it was destroyed by fire.

The 1857 Italianate Meirs house at 129 Meirs Road (County Route 43) has the stature of age, but in that old, venerable family it is still known as "the new house." One of the finest examples of its type in the region, the five-bay house once known as Windrush has a characteristic box form, low-pitched roof with cupola and wide, overhanging cornices. Its commanding presence is enhanced by its locale at the top of a hill. The date is inscribed on downspouts. (Monmouth County Historic Sites Inventory.)

Holmes Mill on Miry Run may date from the early 19th century but was likely under another name. Joseph Holmes Sr. acquired it with the Lawrence farm in 1873, sold it the next year, but it was later in the family, operated by George Bodine Holmes up to his death in 1934. The building was demolished during World War II, its metal salvaged. (Rutgers Special Collections and University Archives.)

Melinda Konover Meirs, later Linda, was born on June 5, 1884, at Cream Ridge and was educated at the Allentown school, the Model School in Trenton, Philadelphia General Hospital, and the Mayo Brothers Clinic. She combined her nursing career with an ambition to travel by visiting a number of the early-20th-century hot spots, beginning with Mexico at the time of their revolution, leaving Mexico City the day before its 1913 bombardment. She served as nurse with the U.S. Army force in pursuit of Pancho Villa. Linda preceded America's entry in World War I, serving with the Red Cross on the Mercy Ship to Kiev, in a Kiev hospital and in at least four other countries, including battlefields in Germany, receiving a number of medals. Her postwar experience in the United States included assignments at the Soshone Indian Reservation, Wyoming, with the Somerset County (New Jersey) Health and Tuberculosis Association and as head nurse in the Public Health Division of Johns-Manville's plant, no doubt unaware of the serious health risks surrounding all there. Linda Meirs retired from Manville, living at times in Virginia, Pennsylvania, and with her family in Cream Ridge. She died in 1972 and is buried in the Meirs family plot in the Presbyterian Cemetery, Allentown.

This brick house at 90 Holmes Mill Road was built in 1915 as a residence for George Bodine and Anna Meirs Holmes following their marriage. The bricks have been painted white, and additions built over the porte cochere and in the rear.

Joseph Holmes Jr. is pictured with his mother, the former Martha Ann Meirs. He married the former Helen Giberson. The two had five children, but only two survived to adulthood, including Geroge Bodine Holmes, who married Anna Meirs, and Martha, who was unmarried. He was president of the First National Bank in Hightstown, and lived in the house pictured on the bottom of page 86.

Charles R. Meirs was son of the Charles who built the house on the bottom of page 40. He is pictured with Lillie, a daughter who married Philip Rowe and was a secretary for the New Jersey Commissioner of Banking and Insurance.

Apollo Meirs was born in 1765, the son of David and the former Martha Swaim. He married twice, first to Unity Shinn, who bore him Martha, John, Thomas, and David, and later to Ann Burtis. Their children were Sarah, Unity, and Charles. He farmed but probably made most of his fortune investing in real estate. Apollo was able to have his portrait painted late in life by George Durrie.

Aart Van Wingerden bought the 134-acre C. Russell Satterthwaite farm on County Route 526, just east of Allentown, in July 1960 for his Kube-Pak organization, then of Pompton Plains. They grow seedlings from seeds, selling wholesale in a patented packaging process whence arises their name. The operation of the still-active business is pictured in 1966, by which time they had 10 million seedlings in 10.5 acres of greenhouses. (Rutgers Special Collections and University Archives.)

Tom Amabile established the Cream Ridge Winery in 1988 as a second career, planning to elevate his early interest in fruit wines to professional stature. Located on County Route 539 (well north of the village), the winery has won a number of awards, recently the 2001 Fruit Wine Governor's Cup. Fruit wines are sweet and typically taste like their fruits of origin. The plant, which can fill 1,000 bottles an hour, has an extensive list; many are sold only in the pictured shop.

Essie and Sadie are pictured some years prior to the *c.* 1950 demise of the massive white oak on Old York Road, about a mile north of New Sharon village. Essie and Sadie point out the tree's girth, but the close-up denies us a view of the height of what the 1938 *Noteworthy Trees of New Jersey* called one of the largest oaks recorded in the state and possibly the tallest of the ancient white oaks. The diseased tree, which reportedly provided shelter during the Revolutionary War, was believed cut down.

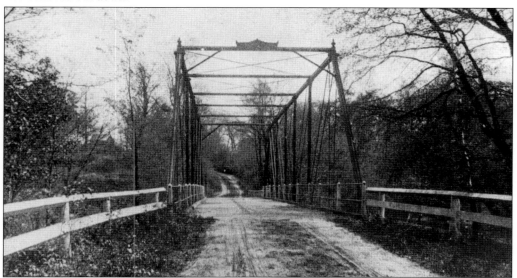

Fowlers Bridge, or County Bridge U53, over Crosswicks Creek on Province Line Road, is Monmouth's oldest span. The Pratt through truss bridge was erected in 1891 by Dean & Westbrook, a New York builder in political favor at the time. This important engineering preservation subject was underpinned in 1994 to assure future viability. That reinforcement makes it a lot more substantial than the wary driver may suspect on his initial approach to the venerable bridge, which looks even narrower to the contemporary eye than it appears in this *c.* 1910 postcard. (Collection of Harold Solomon.)

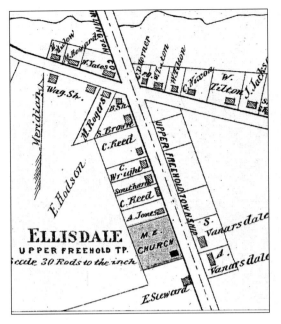

Ellisdale is a small village straddling Monmouth's border with Burlington County, as indicated by Province Line Road, which bisects them on this plan from the 1873 Beers Comstock and Cline *Atlas of Monmouth County*. It was known as Gibbstown when it developed in the 18th century and was later Shelltown, reflecting the rich accumulation of decayed matter that formed nearby marl deposits. Thomas Gordon's 1834 *Gazetteer of New Jersey* describes Shelltown as "on a small branch of Crosswicks Creek; contains some half-dozen dwellings. There is a Friends' Meetinghouse near it, in Monmouth County." The place was renamed *c.* 1870 for early settler Francis Ellis and, by 1873, had the commercial and institutional presence that characterized small villages. Ellisdale-Walnford Road is the street running to the right margin.

Province Line Road is pictured *c.* 1910 looking south from Ellisdale-Walnford Road. The general store on the left, No. 725, is now a private residence with a garage on the visible side. The Hudson house is on the right, No. 950 (on the Burlington side), a two-and-a-half-story brick building now painted white, the first of the several dwellings Gordon mentioned in 1834, with Nos. 946 and 942 visible in the background. (Collection of Glenn Vogel.)

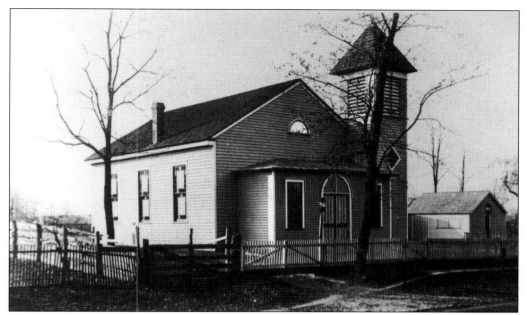

The Ellisdale United Methodist Church was built on the Burlington County side in 1852 when under the charge of the Crosswicks church. The plain, vernacular design is little changed in 2001. A new entry obscures the old doors, and the arched date tablet in the gable is also covered. The fences and garage are gone, but the church is instantly recognizable as a well-preserved example from the mid-19th century. (Collection of Glenn Vogel.)

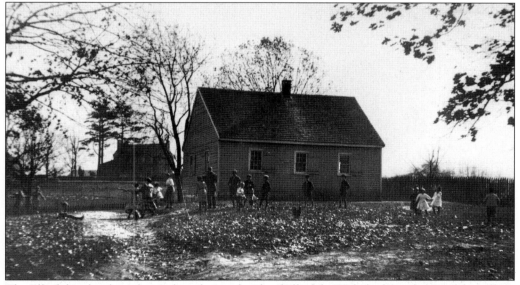

The Ellisdale school was located on the south side of Ellisdale-Walnford Road, east of the village on land donated by George Tilton. Franklin Ellis's 1885 *History of Monmouth County* claimed that a pre-1812 school, which was also used as a Friends meetinghouse, was moved there in 1867. That appears to be the structure in this *c.* 1912 Underwood & Underwood photographic postcard. The former school was reportedly remodeled into a residence. (Collection of Harold Solomon.)

Arneytown is, or was, a small village on the Monmouth-Burlington border that was settled by Friends in the early 18th century, perhaps not long after John Arney bought from Benjamin Borden a piece of land once part of the William Dockwra tract. Joseph Arney and others petitioned the Chesterfield Monthly Meeting at Crosswicks in 1739 seeking to keep their own meeting at his home. The car is pictured in October 1949 turning north on Province Line Road from Arneytown-Hornerstown Road.

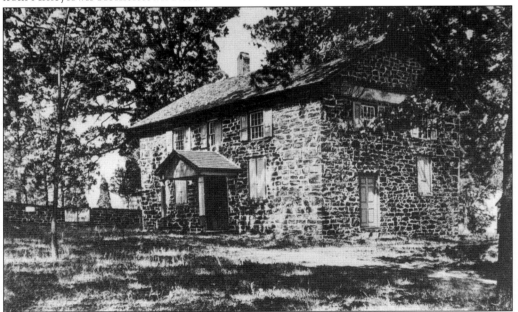

The Friends purchased a plot of about an acre and a half in the mid-18th century, erecting a meetinghouse, perhaps this substantial stone structure, and establishing a cemetery. Meetings had become irregular by 1885 and little is known about the house once located at the southeast corner of Province Line Road and Arneytown-Hornerstown Road. Its demolition date is unknown, but it was gone by the mid-1930s.